Great Type and Lettering Designs

DAVID BRIER

Project Editor

NORTH LIGHT BOOKS

CINCINNATI, OHIO

About the Project Editor

As President and Creative Director of DBD International, Ltd., David Brier, a self-taught designer and typographer, has an impressive list of clients and awards. In addition to being published in a host of professional magazines including *Step-by-Step Graphics*, *Graphis* and *Art Direction*, he has also designed a number of magazine covers ranging from *Rolling Stone* to the *New York Times Magazine*. He also publishes the award-winning "Graphic Relief, a Quarterly Indulgence," a publication that showcases the work of artists, designers, photographers and writers in a creative, innovative and highly aesthetic format.

His client list includes Prudential, The Trump Organization, Turner Broadcasting, Mercedes-Benz, Mobil Oil and Merrill Lynch, among others. He lives and works in Rutherford, New Jersey.

Great Type and Lettering Designs. Copyright © 1992 by North Light Books. Printed and bound in Hong Kong. All rights reserved. No part of this book may be reproduced in any form or by any electronic or mechanical means including information storage and retrieval systems without permission in writing from the publisher, except by a reviewer, who may quote brief passages in a review. Published by North Light Books, an imprint of F&W Publications, Inc., 1507 Dana Avenue, Cincinnati, OH 45207 (1-800-289-0963). First edition.

96 95 94 93 92 5 4 3 2 1

Library of Congress Cataloging in Publication Data

Great type and lettering designs / David Brier, project editor. -- 1st ed.
 p. cm.
 ISBN 0-89134-440-3 (hardcover)
 1. Printing, Practical--Layout. 2. Type and type-founding.
3. Lettering I. Brier, David, 1959-
Z246.G74 1992
686.2'21--dc20 91-44474
 CIP

Edited by Mary Cropper

DEDICATION

I'd like to acknowledge the continuous help and support of Diana Martin, David Lewis and Mary Cropper of North Light Books without whose assistance and persistence this would have been impossible.

This book is further dedicated to all designers, art directors and artists around the globe who have, through their efforts, forwarded typographic beauty, aesthetics and innovation for all to see. This book is dedicated to the pioneers who initially explored some of the new uncharted frontiers of type and design and to whom we are all indebted.

CONTENTS

INTRODUCTION

In celebration of typographic excellence, here is a collection of some of the finest typographic solutions ever produced to showcase the power of typography.

1

TYPE THAT TELLS A STORY

Type was invented to convey ideas with the same result as the spoken word: understanding. But type can do more than that. It can convey a mood or an image or even become the message itself.

2

TYPE THAT BEAUTIFIES A DESIGN

Typography can not only enhance the message but be beautiful in itself whether it is expressed by hand-lettered or hand-rendered letterforms or outstanding use of traditional typefaces.

54

TYPE THAT BREAKS THE RULES

Often type must challenge preconceptions in approach or introduce something unique in order to communicate. Solutions that take this approach challenge notions of what type can—or should—be.

118

CREDITS
153

INTRODUCTION

It's been said that a picture is worth a thousand words. Equally true, yet less well-known, is that a word is worth a thousand pictures. If you know the power of a word and how to manipulate a word to convey a mood, an idea, a story, a lifestyle or whatever, then you truly know the power of a word.

A well-conceived and properly executed typographic solution has power—the power to cut through the morass of messages in today's overcrowded media. Accomplishing this involves creating a fine balance between a technical understanding of typography and a strong sense of design in the translation of a concept into type.

Throughout this book, you'll see works by both well-known and not-so-well-known designers, who have created typographic solutions that do cut through the clutter. Some have accomplished this by applying striking combinations of typefaces to traditional blocks of type. Others have drawn inspiration from calligraphic letterforms to create designs that display precision, daring and beauty—often simultaneously.

In celebration of typographic excellence, therefore, I've brought together in *Great Type and Lettering Designs* a collection of some of the finest typographic solutions ever produced. It is my hope this volume allows you to discover the power of typography.

David Brier

TYPE THAT TELLS A STORY

Type was invented to convey ideas with the same result as the spoken word: understanding. At the very least, then, type must relay information in an easily understood, quickly comprehended manner.

But type can do more than that. In the hands of talented designers, the type itself can become the message. The classic example of this is the logo work of Herb Lubalin—the words take on the shape and form of their subject. And the art of translating words into an image that not only tells but shows the reader what the piece is about continues today in the work of such designer/letterers as David Quay and Oswaldo Miranda.

At other times, the type conveys its message more subtly by establishing a mood, a feeling or an image. The design staff at *Rolling Stone* magazine has become justly famous for their pursuit of type that sets the mood or otherwise establishes a background for each article.

In this first section of the book, you'll find these and many more examples where the type does the talking—either alone or in conjunction with artwork—for the designer and the client.

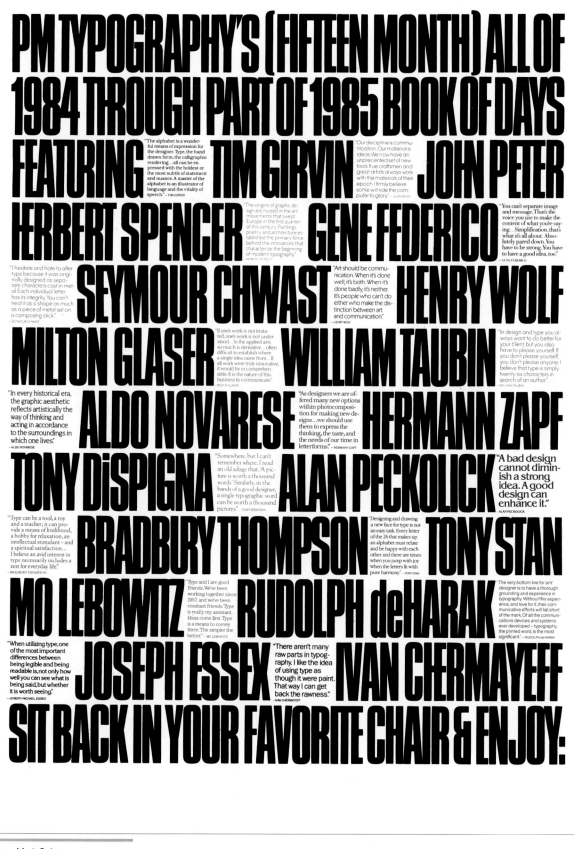

PM TYPOGRAPHY'S (FIFTEEN MONTH) ALL OF 1984 THROUGH PART OF 1985 BOOK OF DAYS FEATURING TIM GIRVIN JOHN PETER HERBERT SPENCER GENE FEDERICO SEYMOUR CHWAST HENRY WOLF MILTON GLASER WILLIAM TAUBIN ALDO NOVARESE HERMANN ZAPF TONY DiSPIGNA ALAN PECKOLICK BRADBURY THOMPSON TONY STAN MO LEBOWITZ RUDOLPH deHARAK JOSEPH ESSEX IVAN CHERMAYEFF SIT BACK IN YOUR FAVORITE CHAIR & ENJOY:

"The alphabet is a wonderful means of expression for the designer. Type, the hand drawn form, the calligraphic rendering...all can be expressed with the boldest or the most subtle of statement and nuance. A master of the alphabet is an illustrator of language and the vitality of speech." – TIM GIRVIN

"Our discipline is communication. Our material is ideas. We now have an unprecented set of new tools. True craftsmen and great artists always work with the materials of their epoch. I firmly believe some will ride the computer to glory." – JOHN PETER

"The origins of graphic design are rooted in the art movements that swept Europe in the first quarter of this century. Paintings, poetry and architecture established the primary force behind the innovations that characterize the beginning of modern typography." – HERBERT SPENCER

"You can't separate image and message. That's the voice you use to make the content of what you're saying. Simplification, that's what it's all about. Absolutely pared down. You have to be strong. You have to have a good idea, too." – GENE FEDERICO

"I hesitate and hate to alter type because it was originally designed as separate characters cast in metal. Each individual letter has its integrity. You can't treat it as a shape as much as a piece of metal set on a composing stick." – SEYMOUR CHWAST

"Art should be communication. When it's done well, it's both. When it's done badly, it's neither. It's people who can't do either who make the distinction between art and communication." – HENRY WOLF

"If one's work is not imitated, one's work is not understood...In the applied arts so much is derivative... often difficult to establish where a single idea came from...If all work were truly innovative, it would be in comprehensible. It is the nature of this business to communicate." – MILTON GLASER

"In design and type you always want to do better for your client, but you also have to please yourself. If you don't please yourself, you don't please anyone. I believe that type is simply twenty six characters in search of an author." – WILLIAM TAUBIN

"In every historical era, the graphic aesthetic reflects artistically the way of thinking and acting in accordance to the surroundings in which one lives." – ALDO NOVARESE

"As designers we are offered many new options within photocomposition for making new designs...we should use them to express the thinking, the taste, and the needs of our time in letterforms." – HERMANN ZAPF

"Somewhere, but I can't remember where, I read an old adage that, 'A picture is worth a thousand words.' Similarly, in the hands of a good designer, a single typographic word can be worth a thousand pictures." – TONY DiSPIGNA

"A bad design cannot diminish a strong idea. A good design can enhance it." – ALAN PECKOLICK

"Type can be a tool, a toy and a teacher; it can provide a means of livelihood, a hobby for relaxation, an intellectual stimulant – and a spiritual satisfaction... I believe an avid interest in type necessarily includes a zest for everyday life." – BRADBURY THOMPSON

"Designing and drawing a new face for type is not an easy task. Every letter of the 26 that makes up an alphabet must relate and be happy with each other and there are times when you jump with joy when the letters fit with pure harmony." – TONY STAN

"Type and I are good friends. We've been working together since 1957, and we've been constant friends. Type is really my assistant. Ideas come first. Type is a means to convey them. The simpler the better." – MO LEBOWITZ

"The very bottom line for any designer is to have a thorough grounding and experience in typography. Without this experience, and love for it, their communicative efforts will fail short of the mark. Of all the communications devices and systems ever developed – typography, the printed word, is the most significant." – RUDOLPH de HARAK

"When utilizing type, one of the most important differences between being legible and being readable is, not only how well you can see what is being said, but whether it is worth seeing." – JOSEPH MICHAEL ESSEX

"There aren't many raw parts in typography. I like the idea of using type as though it were paint. That way I can get back the rawness." – IVAN CHERMAYEFF

Designer: Mark Galarneau
Design Firm: Galarneau & Sinn, Ltd.
Headline Typeface: Compacta Light
Text Typeface: Various
Client: PM Typography
Usage: Folder to house poster calendars

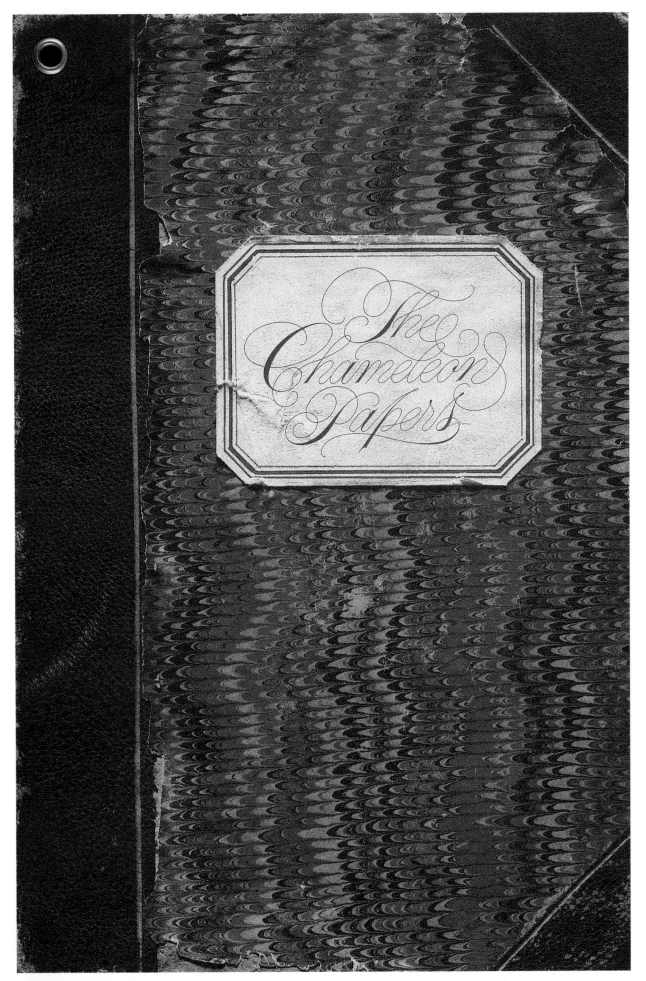

Designers: Robert Cipriani,
 Bruce McIntosh
Letterer: Tony DiSpigna
Design Firm: Cipriani Kremer
 Design Group
Headline Typeface: Hand-
 rendered
Client: Chameleon Papers
Usage: Promotion

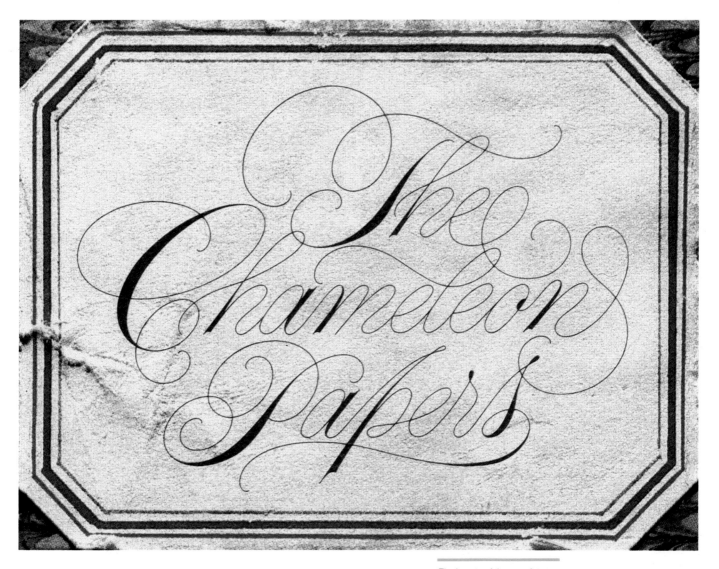

The beauty of these script
letterforms results from
a fluidity unlike any
commercially available
typeface. Nothing need
be replaced or shifted—
it's perfect as it is.

Designer: Herb Lubalin
Design Firm: Lubalin Peckolick
Headline Typeface: Franklin Gothic
Client: New Leader
Usage: Logo

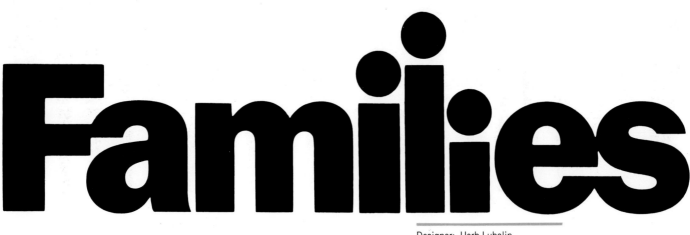

Designer: Herb Lubalin
Letterer: Tony DiSpigna
Design Firm: Lubalin Peckolick
Headline Typeface: Franklin Gothic
Client: Reader's Digest Corp.
Usage: Magazine masthead

M⊕THER

Designer: Herb Lubalin
Letterer: Tom Carnase
Design Firm: Lubalin Peckolick
Headline Typeface: Goudy Old Style
Client: *Ladies Home Journal*
Usage: Magazine masthead

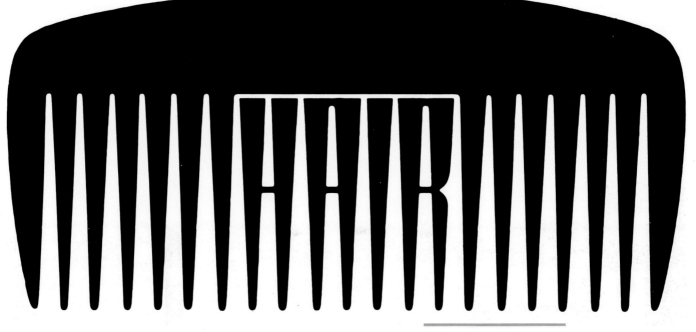

Designer: Woody Pirtle
Letterer: Woody Pirtle
Design Firm: Pentagram
Headline Typeface: Hand-rendered
Client: Mr. and Mrs. Aubrey Hair
Usage: Logo

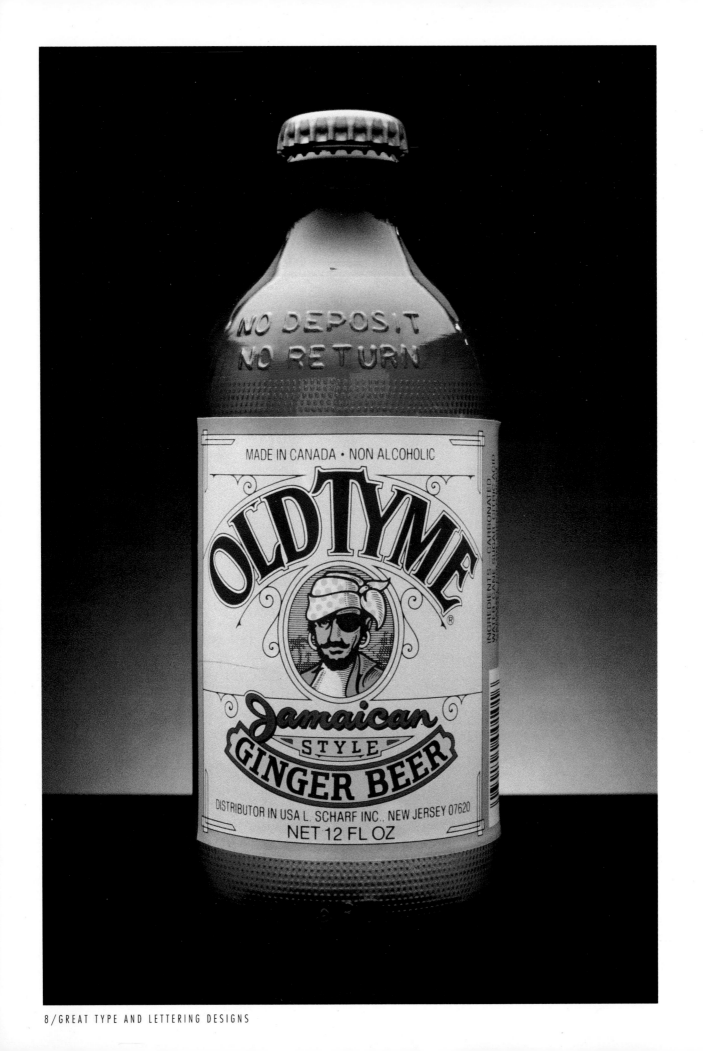

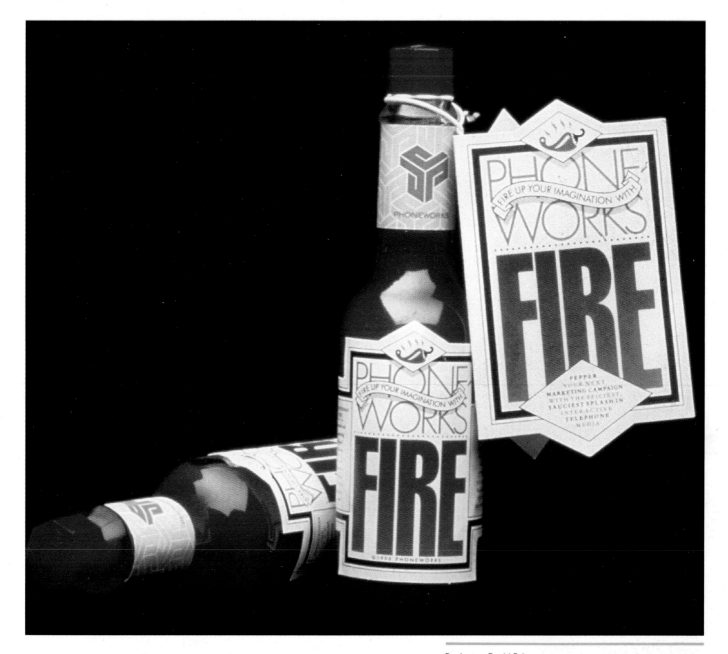

Designer: David Brier
Design Firm: DBD International, Ltd.
Headline Typeface: Futura Light & Helvetica Extra Compressed
Text Typeface: Futura Book & Bembo
Client: Phoneworks
Usage: Promotional mailer

Art Director: Phil Gips, Gips & Balkind
Designer/Letterer: Gerard Huerta
Design Firm: Gerard Huerta Design, Inc.
Primary Typeface: Hand-lettered
Client: Old Tyme
Usage: Soft drink label design

Designer: Tom Carnase
Letterer: Tom Carnase
Design Firm: Carnase, Inc.
Headline Typeface: Hand-
 rendered
Client: Big City Productions
Usage: Logo

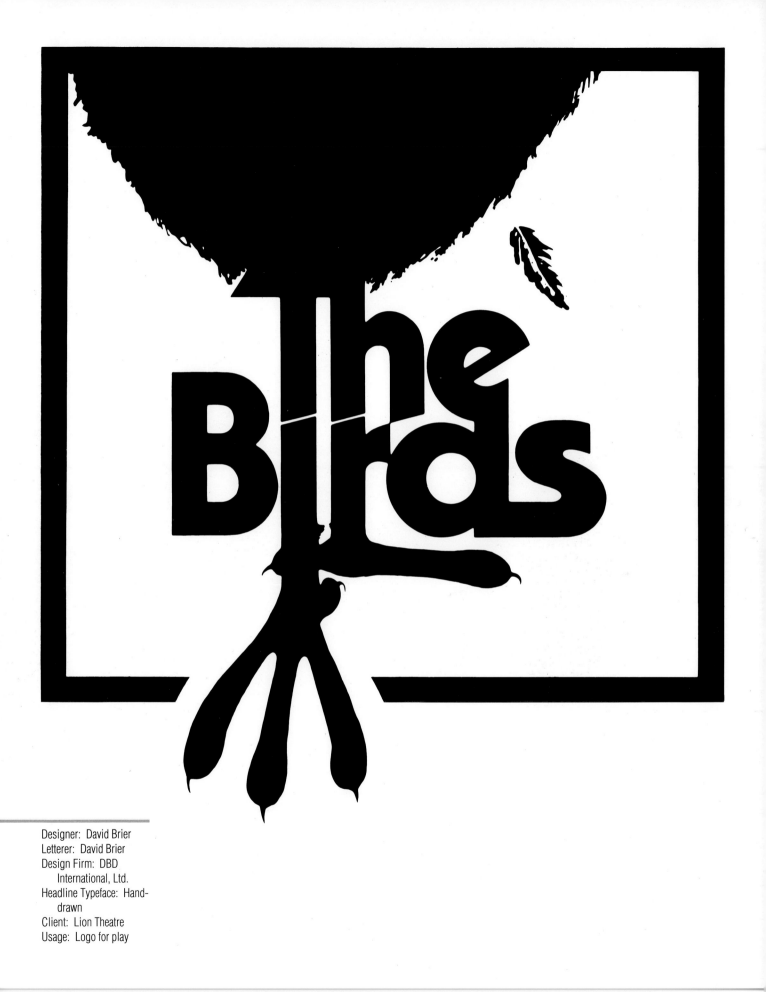

Designer: David Brier
Letterer: David Brier
Design Firm: DBD
 International, Ltd.
Headline Typeface: Hand-
 drawn
Client: Lion Theatre
Usage: Logo for play

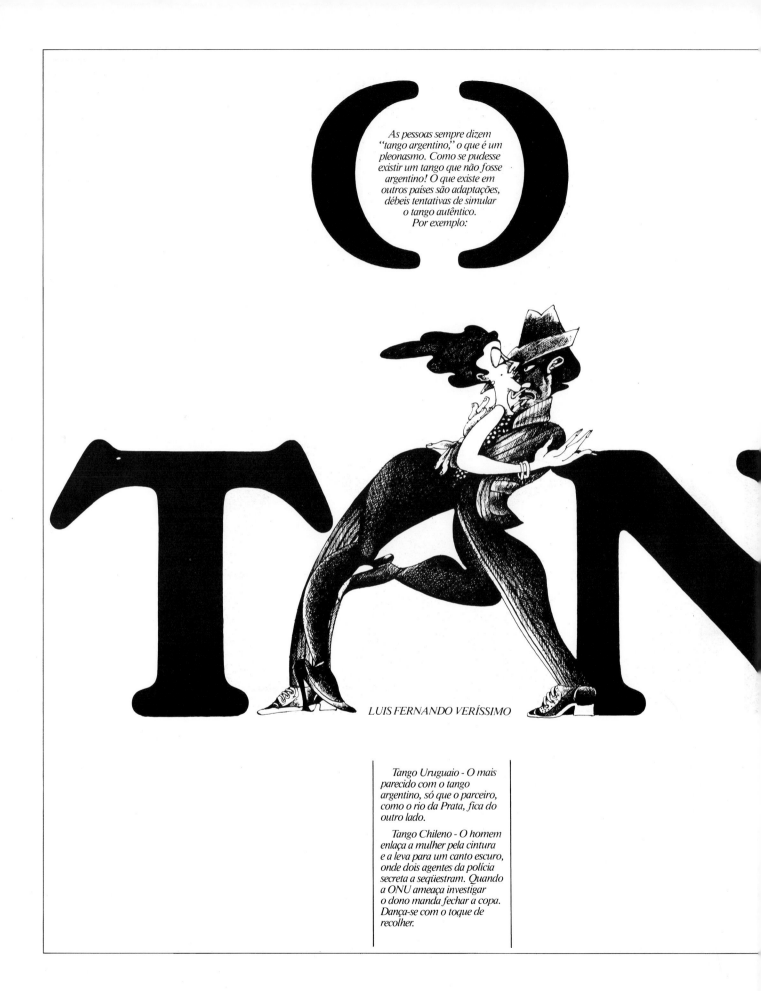

As pessoas sempre dizem "tango argentino," o que é um pleonasmo. Como se pudesse existir um tango que não fosse argentino! O que existe em outros países são adaptações, débeis tentativas de simular o tango autêntico.
Por exemplo:

LUIS FERNANDO VERÍSSIMO

Tango Uruguaio - O mais parecido com o tango argentino, só que o parceiro, como o rio da Prata, fica do outro lado.

Tango Chileno - O homem enlaça a mulher pela cintura e a leva para um canto escuro, onde dois agentes da polícia secreta a seqüestram. Quando a ONU ameaça investigar o dono manda fechar a copa. Dança-se com o toque de recolher.

Designer: Oswaldo Miranda
Design Firm: Miran Studio
Headline Typeface: Windsor
 Bold
Text Typeface: Times New
 Roman Italic
Client: *Raposa* Newspaper
Usage: Double page spread
 in newspaper magazine

The preceding spread is a small sampling of work designed and produced by Galarneau, Deaver and Sinn.

Usually in a self-promotional piece of this sort, one is supposed to cover the process of creative problem-solving, understanding the client's communication and marketing objectives, generating results through innovative design, and all of those wonderful things.

But we decided against that, for one simple reason:

We were stuck.

No matter how hard we tried, we just couldn't come up with anything that sounded right.

Which left us with three alternatives:

1. Stick with it. Keep trying until the problem is solved, which would mean holding up the production of this brochure, which in turn would be totally unacceptable because it was already two months overdue.

2. Scrap the whole thing. Admit defeat. Meaning we'd have to find something to fill these two pages. Or delete them altogether. But who ever heard of a 30-page plus cover?

3. Redefine the problem. Who knows, maybe there's an easier solution. Besides, we'd rather spend the time on the board anyway.

We decided to go with number three.

We'll simply state what we believe in, what we do, who we are, and how we do it.

The quotes on the front cover pretty much sum up our thoughts on design—so that takes care of that. We doubt very much anybody can say it better than those guys anyway.

The samples on the following twenty-four pages demonstrate our capabilities.

Which leaves us with only two more things: Who we are and how we do it.

Now that's simple.

We are Mark Galarneau, Georgia Deaver and Paul Sinn—three designers with a very special interest in type and lettering.

How we do it?

Easy. We work. Hard.

And love every minute of it.

Designers: Paul Sinn, Mark Galarneau, Georgia Deaver
Letterer: Initial cap: Georgia Deaver
Design Firm: Galarneau, Deaver & Sinn
Primary Typeface: Century Oldstyle
Client: Galarneau, Deaver & Sinn
Usage: Self-promotion piece for Galarneau, Deaver & Sinn

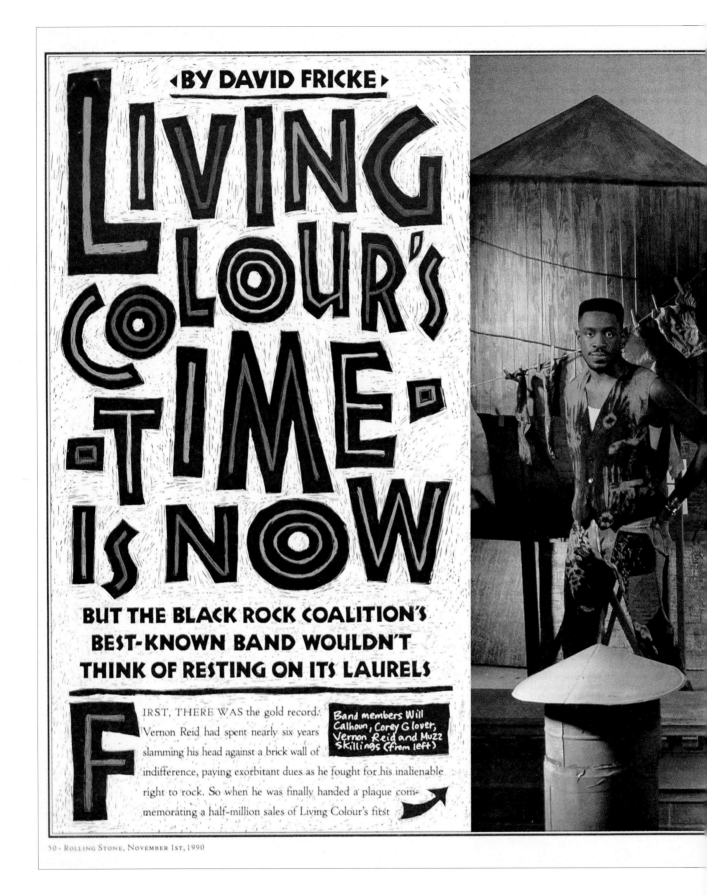

‹BY DAVID FRICKE›

LIVING COLOUR'S ·TIME· IS NOW

BUT THE BLACK ROCK COALITION'S BEST-KNOWN BAND WOULDN'T THINK OF RESTING ON ITS LAURELS

FIRST, THERE WAS the gold record. Vernon Reid had spent nearly six years slamming his head against a brick wall of indifference, paying exorbitant dues as he fought for his inalienable right to rock. So when he was finally handed a plaque commemorating a half-million sales of Living Colour's first

Band members Will Calhoun, Corey Glover, Vernon Reid and Muzz Skillings (from left)

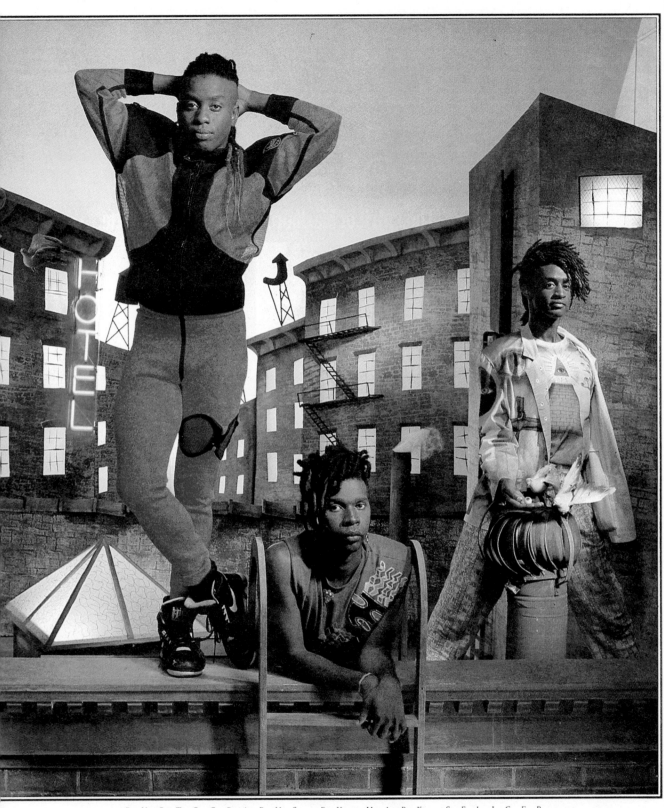

PHOTOGRAPHS BY MARK SELIGER

Designer: Gail Anderson
Design Firm: Rolling Stone
Headline Typeface: New Land Inline, Modified
Text Typeface: Cloister
Client: *Rolling Stone*
Usage: Opening spread of magazine article

BOXES

Designer: Tim Girvin
Letterer: Tim Girvin
Design Firm: Tim Girvin Design, Inc.
Headline Typeface: Hand-rendered
Client: Boxes
Usage: Corporate identification

SOFT SCULPTURE

Designer: Tim Girvin
Letterer: Tim Girvin
Design Firm: Tim Girvin Design, Inc.
Headline Typeface: Hand-rendered
Client: Bloomingdale's
Usage: Newspaper advertisement

UNSPOKEN

emotions

Designer: Tim Girvin
Letterer: Tim Girvin
Design Firm: Tim Girvin Design, Inc.
Headline Typeface: Custom
Client: Bloomingdale's
Usage: Store concept / Dept. section

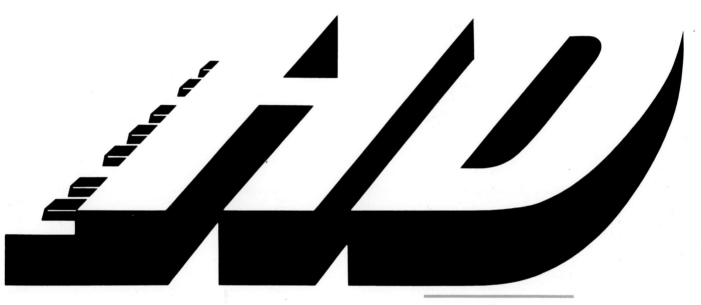

Designer: David Brier
Letterer: David Brier
Design Firm: DBD International, Ltd.
Headline Typeface: Hand-drawn
Client: Harold Danko, pianist
Usage: Logo

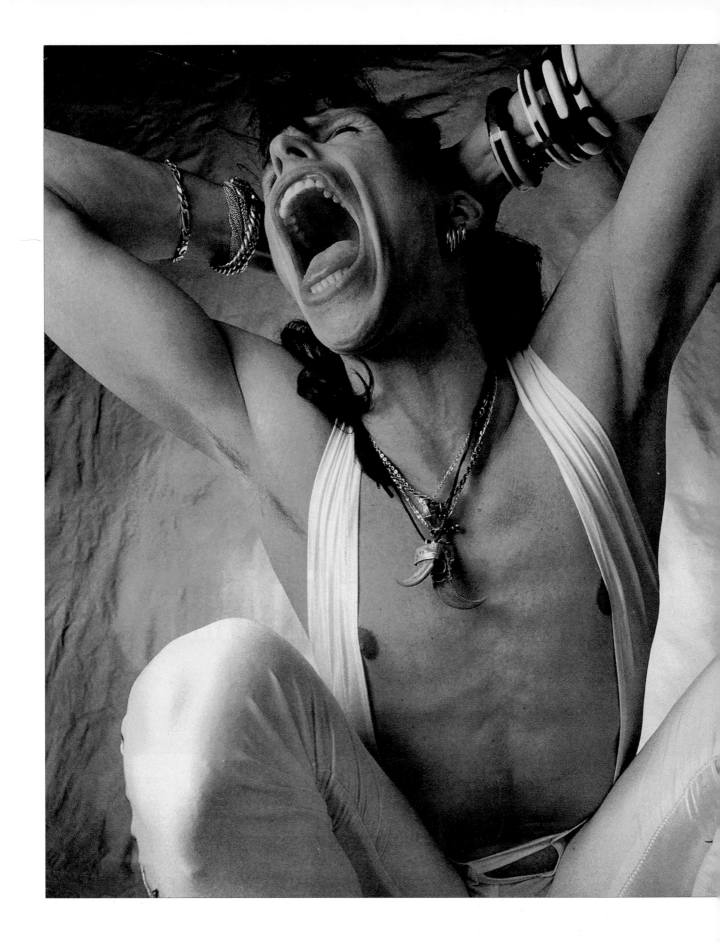

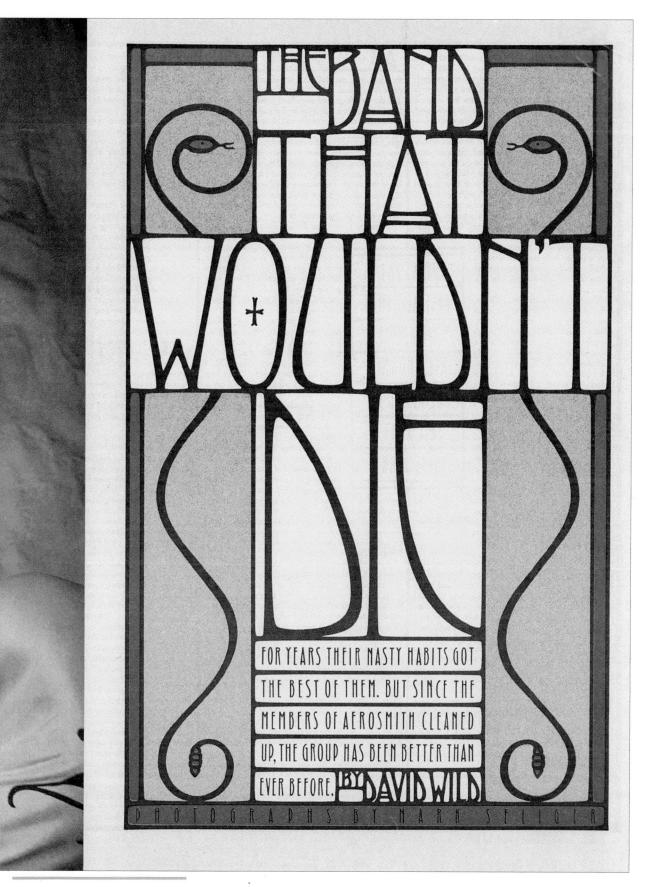

The Band That Wouldn't Die

FOR YEARS THEIR NASTY HABITS GOT THE BEST OF THEM. BUT SINCE THE MEMBERS OF AEROSMITH CLEANED UP, THE GROUP HAS BEEN BETTER THAN EVER BEFORE. BY DAVID WILD

PHOTOGRAPHS BY MARK SELIGER

Designer: Debra Bishop
Design Firm: Rolling Stone
Headline Typeface: Based on Shriften
Text Typeface: Binner Gothic
Client: *Rolling Stone*
Usage: Opening spread of magazine article

Designer: David
 Brier
Letterer: David
 Brier
Design Firm: DBD
 International,
 Ltd.
Headline Typeface:
 Hand-drawn
Text Typeface:
 Goudy Oldstyle;
 Magnum Gothic
 Light
Client: DBD
 International
 Book Division
Usage: Poster

An Invitation To The Most Unique International Design Event Of The Decade...In Fact, The Only One Of Its Kind.

THE PANEL OF JUDGES FOR A DECADE OF TYPE RECENTLY EXCHANGED THOUGHTS ON THIS HISTORIC EVENT:

"A DECADE OF TYPE may be *the* single document to chronicle, in detail, the typographic revolution in editorial, promotional, corporate, and advertising design of the '80s." KIT HINRICHS

"By looking at what others have done, you find out about your own strengths and weaknesses. And if you want to look at everybody else's work, you've got to show them yours." ERIK SPIEKERMANN "I've always loved great typography. A DECADE OF TYPE offers every

designer a-once-in-a-lifetime (or, *at least*, a once in a decade) opportunity for recognition of work done in the past ten years." **FRED WOODWARD** "In this age of computer-aided typography, sound typographic standards become even more necessary. A DECADE OF TYPE will provide them. Everyone should participate, as this will be *the* who's who reference for the '90s." **DAVID BRIER** Your participation is welcome.

BE A PART OF THIS INTERNATIONAL COLLECTION OF THE FINEST TYPOGRAPHIC DESIGNS DONE FROM 1980 THROUGH 1990. FOR INFORMATION AND ENTRY FORMS, CALL 201-896-8476 (USA).

DEADLINE
15
JANUARY
1991
A DECADE OF TYPE

DESIGN: DAVID BRIER, RUTHERFORD, NEW JERSEY. PAPER: CIRCA SELECT, GRAY CRYSTALS COVER, 50% RECYCLED (10% POST-CONSUMER WASTE), FOX RIVER PAPER COMPANY, APPLETON, WISCONSIN. PRINTING: BELL PRESS, BELLEVILLE, NEW JERSEY. TYPESETTING: NEWTYPE, CLIFTON, NEW JERSEY

ENTRANTS WHOSE WORK IS SELECTED WILL RECEIVE A SPECIAL COMMEMORATIVE VERSION OF THIS POSTER AUTOGRAPHED BY EACH OF THE JUDGES.

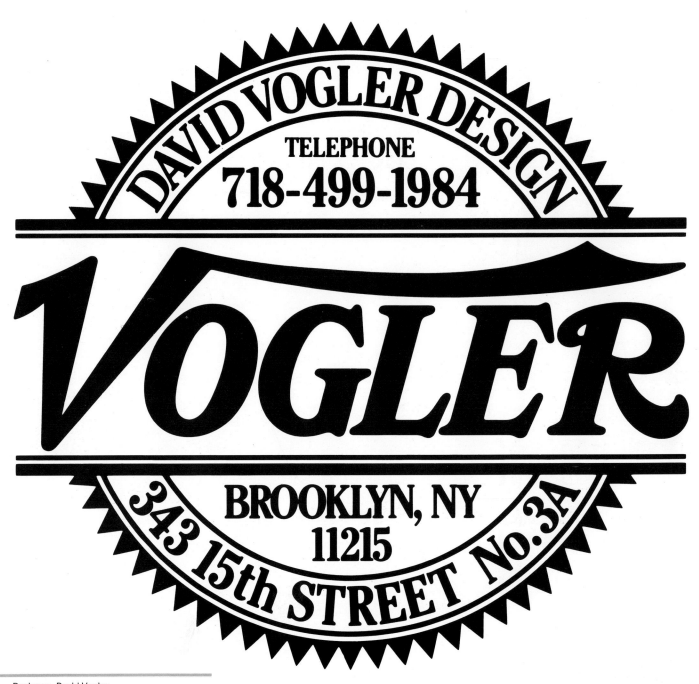

Designer: David Vogler
Letterer: Ray Barber
Design Firm: David Vogler Design
Headline Typeface: Hand-rendered
Text Typeface: ITC Cheltenham Bold Condensed
Client: David Vogler Design
Usage: Logo

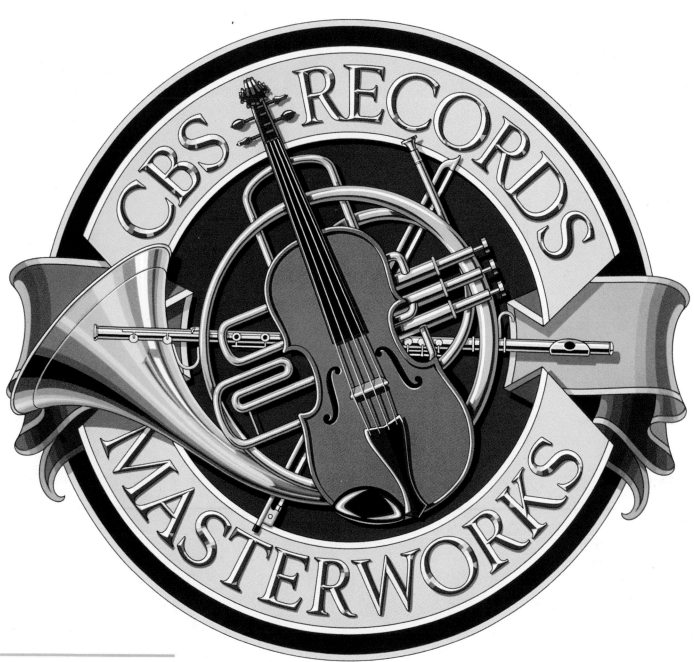

Art Director: Lou Dorfsman, CBS
Designer/Letterer: Gerard Huerta
Design Firm: Gerard Huerta Design, Inc.
Headline Typeface: Hand-lettered
Client: CBS Records
Usage: Logo

Designer: David Quay
Letterer: David Quay
Design Firm: David Quay
 Design
Headline Typeface: Hand-
 rendered
Client: Historical Pen Society
Usage: Logo

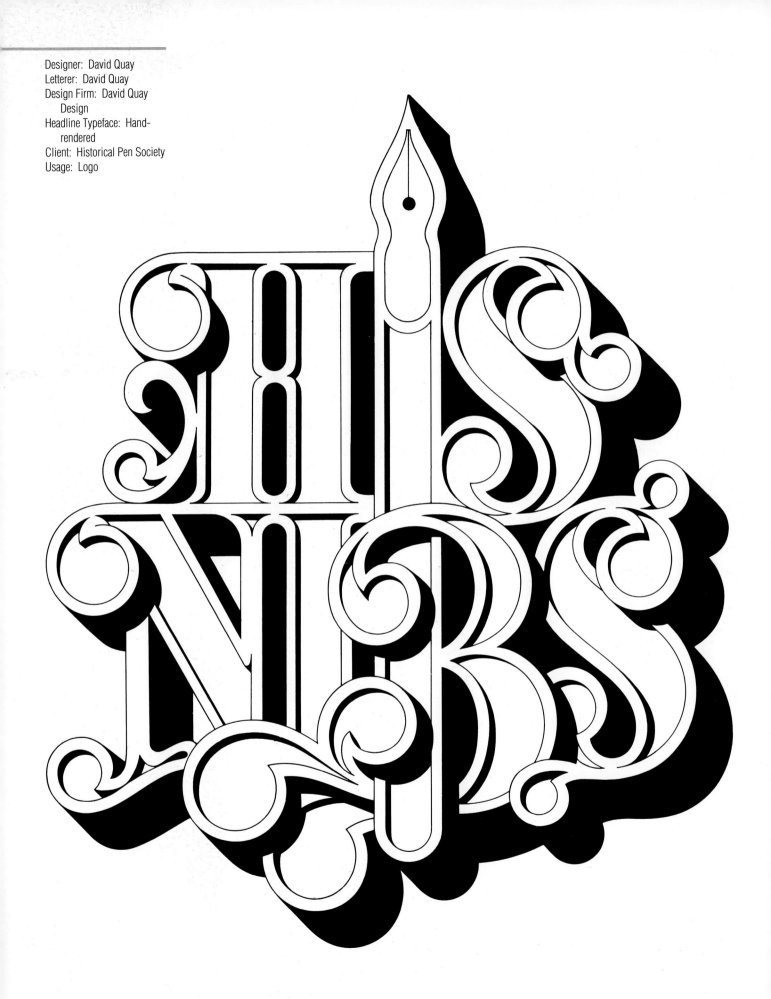

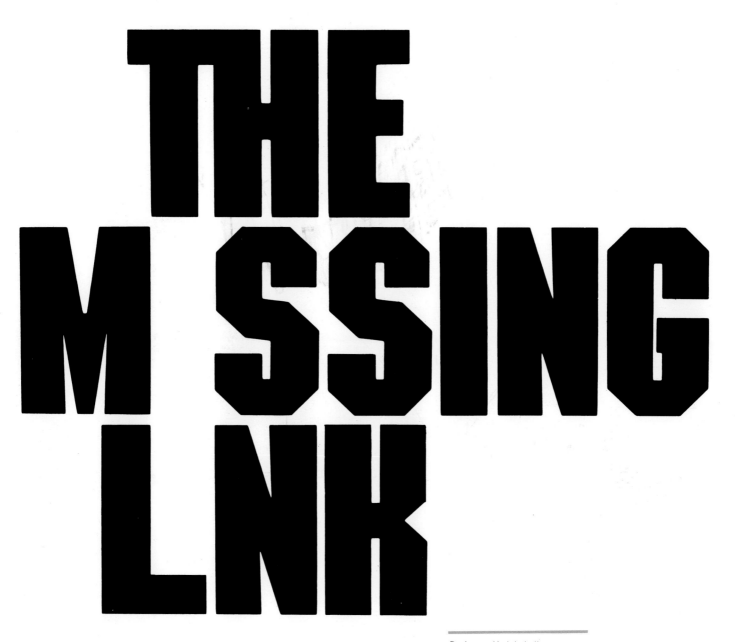

Designer: Herb Lubalin
Design Firm: Lubalin Peckolick
Headline Typeface: Machine Bold
Client: PBS
Usage: TV identification

See the Garamond Bold a? Kind of boring, isn't it? You've seen it 10,000 times already. It could hardly raise the blood pressure of anyone but the most confirmed typoholic. What if we gave you the power to transform it? To make it dimensional, or make it glow or seem to hover above the page? If you had the power, how would you use it?

Designer: James Hellmuth
Design Firm: James
 Hellmuth Design
Text Typeface: Garamond
Client: Phil's Photo
Usage: Envelope

DON'T LEAVE ENGLISH WITHOUT US

We're now a communications link to the world, offering the capabilities of Spectrum Multi-Language Communications, a unique member of our corporate family and North America's largest and oldest foreign language translation and typography organization. Whether it's an ad set in Arabic, a catalog in Chinese, a slide show in Spanish, a package in Portuguese, or the label in Lithuanian, you can count on work that's correct and attractive in any language. There is no longer the need to search for sources or settle for second-best when your international project calls for any foreign language. From the most common tongues to the more exotic, expert translations and full service typography are always available with the same convenience, quality, and performance you've always depended upon. Just phone and we'll give you the world.

Arrow Typographers Inc.
2-14 Liberty Street
Newark, NJ 07102/622-0111

Designer: Bud Renshaw
Design Firm: Arrow Typographers, Inc.
Headline Typeface: Toronto Sans Serif (modified)
Text Typeface: Galliard Italic and Helvetica Bold
Client: Arrow Typographers, Inc.
Usage: Mailing envelope

Simpson Filare

ITALIAN GRAPHIC DESIGN

DIMENSIONS

ISSUED BY THE

SIMPSON PAPER CO.

COMPANY RAILROAD

—FOR PASSAGE ON—

ARCATA & MAD RIVER R.R.

Tkt Ag't. S.P.C.R.R.

TICKET

TICKET

1

Art Director: James Cross
Designer: Michael Mescal
Design Firm: Cross Associates, Los Angeles
Headline Typeface: Bodoni Bold
Client: Simpson Paper Company
Usage: Promotional brochure for Filare Paper

Designers: Carol Fulton, Norman Orr
Design Firm: Jacobs, Fulton Design Group
Headline Typeface: Various
Client: Simpson Paper Company
Usage: Paper promotion

THE ALPHONSE CAPONE ENTERPRISES ANNUAL REPORT 1931

This is a terrific period piece in which the type has been made symmetrical through considerable typographic cheating. The designer has used unorthodox letterspacing and manipulated the letterforms to create the illusion of perfect balance, i.e., the drop cap C has been compressed and slightly flattened while the O has been disproportionately enlarged. The result definitely justifies the means.

Designers: Steven Jacobs, Carol Fulton, Ed Jaciou
Design Firm: Jacobs, Fulton Design Group
Headline Typeface: Custom
Client: Simpson Paper Company
Usage: Paper promotion

ERIC BAKER AND TYLER BLIK

TradeMarks OF THE '20'S & '30'S

WITH AN INTRODUCTION BY PRIMO ANGELI

Art Directors: Eric Baker, Tyler Blik
Designer: Michael Doret
Design Firm: Eric Baker Design Associates
Headline Typeface: Hand-rendered
Text Typeface: Kabel
Client: Chronicle Books
Usage: Trade book

Art Directors: Eric Baker, Tyler Blik
Designer: Michael Doret
Design Firm: Eric Baker Design Associates
Headline Typeface: Hand-rendered
Text Typeface: Poster Bodoni
Client: Chronicle Books
Usage: Trade book

Designer: James Hellmuth
Design Firm: James Hellmuth Design
Headline Typeface: Modified Gothic/Blue Skies
Client: Phil's Photo
Usage: Title page of book

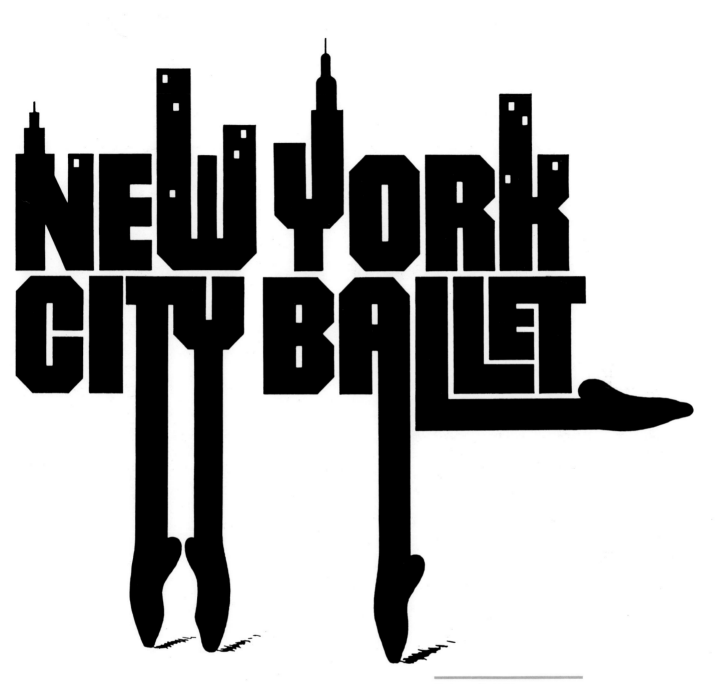

Designer: David Brier
Letterer: David Brier
Design Firm: DBD International, Ltd.
Headline Typeface: Hand-drawn
Client: New York City Ballet
Usage: Logo

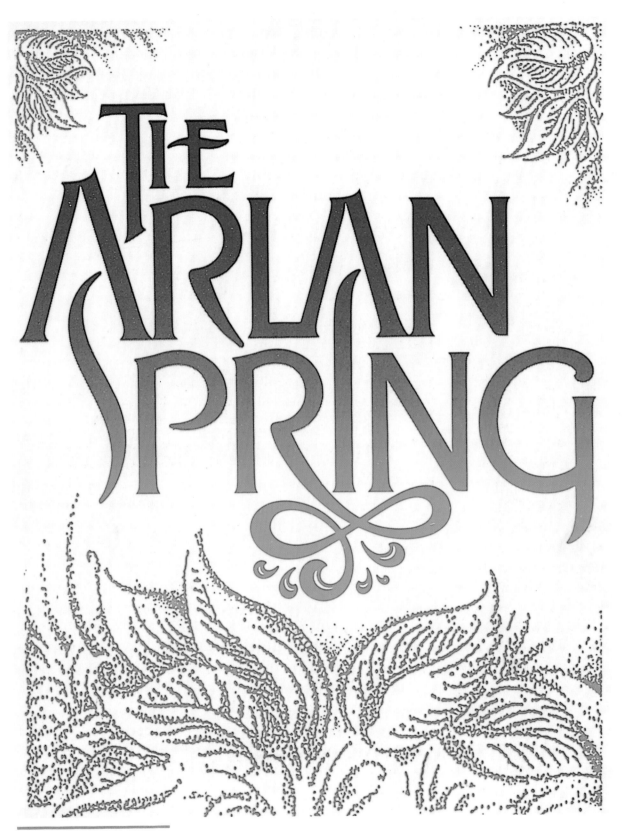

THE ARLAN SPRING

Designer: David Brier
Letterer: David Brier
Design Firm: DBD International, Ltd.
Headline Typeface: Hand-drawn
Text Typeface: Hand-drawn
Client: Arlan Spring
Usage: Identity for water purifier

Designers: Paul Sinn, Mark Galarneau, Georgia Deaver
Design Firm: Galarneau, Deaver & Sinn
Primary Typeface: Various
Client: Galarneau, Deaver & Sinn
Usage: Self-promotion piece for Galarneau, Deaver & Sinn

"Design is an attitude."
L Moholy-Nagy

"Graphics need to reflect the nature and purpose of the proposition. Design is not merely a matter of 'taste', it is an understanding of the problem. Does it fulfill the function? Will it capture attention? Can it sustain interest? If the solution doesn't incorporate these criteria then it probably doesn't work – it's really as simple as that. Although graphic design is not necessarily an art, it is even less a science. In the end there is only one universal test, 'Does it work?' and only one universal principle, 'Could it have been better?'" John McConnell

"For modern advertising and for the modern exponent of the form, the individual element – the artist's 'own touch' – is of absolutely no consequence." El Lissitzky

"It is a primary function of the designer to be an innovator: not to impose his fancies on a reluctant market, but to extend the horizons and enhance the lives of the users. It is palpably true that no innovation worthy of the name ever resulted from market research or indeed any other enquiries into people's needs and wants. The true innovator therefore is always the individual, answerable, in the first place at least, only to himself." Kenneth Grange

"Design comes from a combination of intelligence and artistic ability. A designer is someone who should solve problems. He is a borrower, co-ordinator, assimilator, juggler, and collector of material, knowledge and thought from the past and present, from other designers, from technology and from himself. His style and individuality come from the consistency of his own attitudes and approach to the expression and communication of a problem. It is a devotion of the designer to the task of fully understanding the problem and then expressing those ideas which come from this search in its appropriate form that make him a professional.

There is a large body of designers, clients and consumers who don't really care very much about very much. The joy and pleasure of doing a good job for its own sake has not been discovered by enough people." Ivan Chermayeff

"A design is not to be confused with its end purpose. The end purpose of design is not necessarily aesthetically pleasing; it can be so, it often is so, but it need not be so.

A design is a plan to make something. If the plan works, then the product (not the design, but the product) is appropriate, or truthful, or functional or whatever. If the plan demands aesthetic standards, and it works, then the product is beautiful or elegant or whatever. If the purpose of the plan is to make something which was not there before, and it works, then the designer who is concerned with that process is creative. If the plan needs techniques and skills to succeed, and it succeeds, then the designer can also be complimented as a professional." Peter Gorb

"As designers we are, as a group, measurably responsible for the visual form of our culture. We are the funnels through which the possibilities of technology and the requirements of trade are expressed in terms of experience of people. Perhaps one of our problems is to learn how to provide people with experiences that will open them to growth. I suppose it is important to make people feel something; not just dangle an image before their eyes, but open up a successful communication and if possible, transform somebody's attitude toward something." Saul Bass

"The printed page is not primarily a medium for self-expression. Design for print is not Art. At best it is a highly skilled craft. A sensitive, inventive, interpretive craft, if you will, but in no way related to painting.

The immature avant-garde designer seems bitter about the mainstream of American advertising. He hates the 'hard-sell' and avoids clients who interfere with his freedom. He believes that the role of business should be one of patron of the Arts, and insists that his craft is art.

I do not argue for the return to any form of traditionalism. I do argue for a sense of responsibility on the part of the designer, and a rational understanding of his function.

I think he should avoid designing for designers.

I suggest that the word 'design' be considered as a verb, in the sense that we design something to be communicated to someone." William Golden

"There is an old romantic idea that intuition and intellect do not mix. There is an equally erroneous belief that inspiration takes the place of industry. Fortified with such misconceptions, it is understandable that we tend to minimize the importance of learning the rules, the fundamentals, which are the raw material of the artist's craft.

In graphic design, as in all creative expression, art evolves from craft. In dancing, craft is mastering the basic steps; in music, it is learning the scales.

In typographic design, craft deals with points, lines, planes, picas, ciceros, leads, quads, serifs, letters, words, folios, pages, signatures, paper, ink, color, printing, and binding.

The vocabulary of form (art) includes, among others: space, proportion, scale, size, shape, rhythm, repetition, sequence, movement, balance, volume, contrast, harmony, order, and simplicity.

Just as there is no art without craft and no craft without rules, so too there is no art without fantasy, without ideas. A child's art is much fantasy but little craft. It is the fusion of the two that makes the difference." Paul Rand

"The use of words – their sounds, their meanings, and their collective letterforms – has been an intriguing aspect of design since the invention of the alphabet. Contemporary designers continue to use this play with words in their design concepts. A picture may be worth a thousand words, but as one wit pointed out: It takes words to say that."
Allen Hurlburt

"For a number of reasons – good and bad – design is a confusing subject. Among the good reasons is the elusiveness of definition: a person who does a line of dresses for a couturier house and someone who draws a plan for a jet engine are both called designers. Each arrives at solutions within a context: money limitations, materials available, skills and tools at hand, existing state of the art, competition.

A design may be very beautiful, but it is not art; a design has to do something. The artist works to make a kind of visual statement that has, for him, some important connection with reality as he perceives it. The designer needs a client to present a problem, and a factory to make his design in quantity.

The scientist believes that problems can be solved with his intellectual equipment plus instruments. His answers are always quantifiable. The designer goes along with this to a great extent, but he also relies on the evidence of his senses and his intuition. So his work falls somewhere between art and science." George Nelson

"The thing that is so hard for us to do is look at problems from something other than the designer's point of view. We agonize over the difference between Caledonia and Fairfield. The people that we deal with can hardly tell the difference between typewriter type and Futura. It's hard to get away from limited perspectives that we have. If you are going to be any good as a designer, you have to have a tendency – and I think this is essential – to limit your view."
Lou Danziger

"Type is a thing of constant interest… It is sometimes a serious and useful tool, employed to deliver a message, sell a specific article or give life to an idea.

At other times it is a plaything that affords personal amusement and recreation. It is fun to produce fresh designs and unexpected ideas with letters and numbers – by themselves, or together with other graphic objects. Type is a medium of philosophical enjoyment. It is interesting to discover typographic rules containing inconsistencies in logic, which are in use only because of tradition. It is also interesting to ponder the origin of these errors, the practical reasons for their perpetuation, and to suggest remedies.

An interest in Type provides a broader knowledge of history, including the appreciation of such related arts as painting, architecture and literature – and even business and politics. This affords opportunity for pleasant romantic indulgence. At the same time, it develops confidence in one's practical ability to specify appropriate type faces to accompany creative work of specific periods.

In short, Type can be a tool, a toy and a teacher; it can provide a means of livelihood, a hobby for relaxation, an intellectual stimulation – and a spiritual satisfaction.

I believe an avid interest in Type necessarily includes a zest for everyday life." Bradbury Thompson

"The designer should not be led in his work by his egotistic urge to offer something radically new, to flatter, to comfort the reader with a sphinx-like enigma, but rather common sense should be the foremost guide in his work. For what may be acceptable to us experts may not be good for the largely untrained readers."
Max Caflisch

"Americans, unlike the Europeans, are a homogeneous group made up of many nationalities and ethnic backgrounds. Because of this, we possess the most colorful language in the world. The American language is humorously voluptuous. It is a creative language that thus defies rigid typographical principles and encourages the many means of conceptual typographic exploitation. Precise intellectual design is not our bag; ideation is." Herb Lubalin

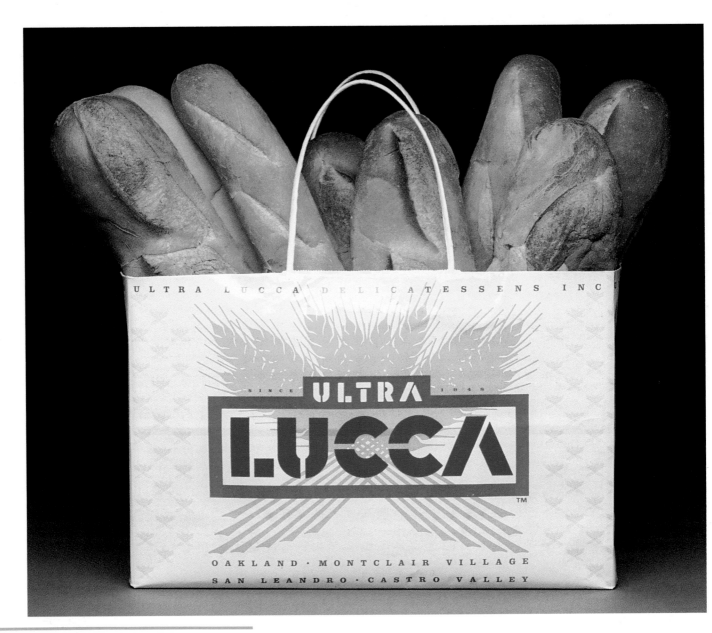

Designer: Primo Angeli
Letterer: Primo Angeli
Design Firm: Primo Angeli, Inc.
Headline Typeface: Hand-rendered; derived from Futura
Text Typeface: Craw Clarendon
Client: Ultra Lucca Delicatessens
Usage: Logo

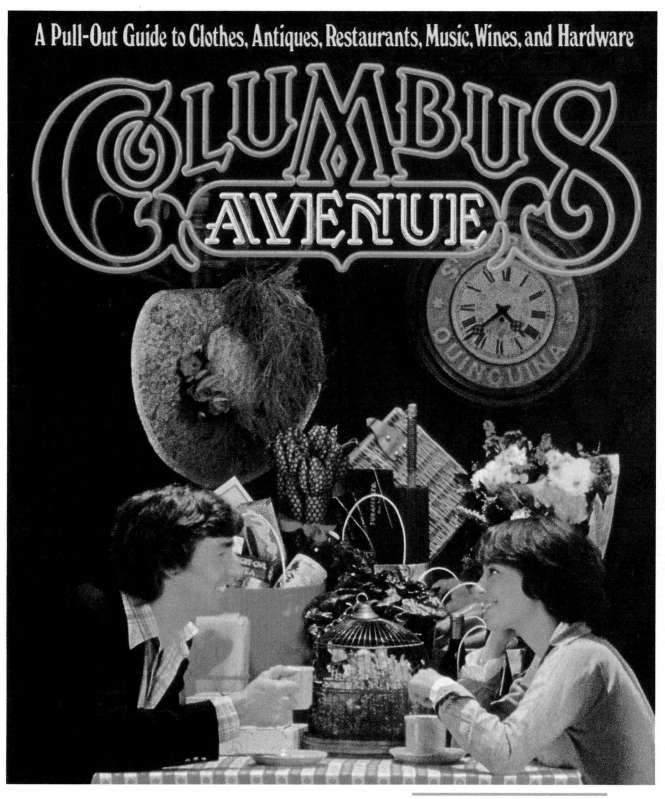

A Pull-Out Guide to Clothes, Antiques, Restaurants, Music, Wines, and Hardware

COLUMBUS AVENUE

Art Director: Walter Bernard, *New York* Magazine
Designer/Letterer: Gerard Huerta
Design Firm: Gerard Huerta Design, Inc.
Headline Typeface: Hand-rendered
Client: *New York* Magazine
Usage: Cover headline

Designer: David Brier
Design Firm: DBD
 International, Ltd.
Headline Typeface: Lubalin
 Graph
Text Typeface: ITC Garamond
 Italic; various weights
Client: Boardroom Reports
Usage: Promotional poster

WHO'S WHO SAYING WHAT'S WHAT—DIRECT MARKETING RULES OF THUMB & OTHER ACCUMULATED WISDOM.

After identifying the audience for your offer, and after exhausting lists specific to your market, t... on larger, less tar... expand the availa... of names.

RALPH STEVE...
PRESIDENT • WOODRUFF-STEVE...

Performance c... similar or rela... is almost always more important t... demographics and psychographics... the usage on a list from other mai... is the best indication of whether a... work well for you.

DAVID W. FLORENCE
CHAIRMAN • DIRECT MEDIA, INC.

Problems are opportunities in work clothes. Opportunities are problems in ambush.

WALTER MARSHALL
PARTNER • CIRCULATION MANAGEMENT SERVICES, INC.

List testing is a direct marketer's most important investment for the life of the product.

CAROLE MANDEL
DIRECTOR OF CORPORATE DEVELOPMENT • BOARDROOM

If you are unfamiliar with the list, ask to see the promotiona... got the name.

ANNETTE BRODSKY
EXECUTIVE VICE-PRESIDENT • ACCREDITED MAIL...

Rules to live by for a service bureau:

1) The customer is always right; 2) When the customer is wrong, go look at rule number one.

• BIFF BILSTEIN
DIRECTOR OF MARKETING • NEODATA SERVICES

There are si... of human a... duty, pride, and self-pre...

MEMBER...

Don't advertise the book they published, advertise the one they should have published.

MEL MARTIN
BOARDROOM'S COPYWRITING GURU

v of no mail business that rvive with- eat business.

MAX HABERNICKEL
NT • HABAND COMPANY, INC.

Work with a broker you can trust, and whose expertise most closely matches what you want to do in the mail. No matter which company you select, the individual who will work on your account matters most.

HENRY DiSCIULLO
ACCOUNT EXECUTIVE • THE GUILD COMPANY

rlays ists to niverse

You cannot hit a list too often. The only criterion is—will it pay out?

B. L. MAZEL
CHAIRMAN OF THE BOARD • BRUNNER MAZEL INC.

First find a market with a high level of excitement, with lists capable of reaching that market. Then develop a product to fit it.

JACK OLDSTEIN
PRESIDENT • DEPENDABLE LISTS

, INC.

st for ailers its ck This ill

The strategic center for direct marketers in the next decade and beyond will be the data processing room. Here will be the opportunity to subdivide customers and prospective customers by purchasing behavior and lifestyle. Here also will be the opportunity for product differentiation, new product development, and personalized promotions.

C. ROSE HARPER
PRESIDENT • THE KLEID COMPANY INC.

Try phrasing your lead at least six different ways on the first sheet of paper you put into your typewriter.

MAXWELL C. ROSS
MAXWELL C. ROSS & COMPANY

Experience allows you to suggest list tests; not predict.

EUGENE SCHWARTZ
EUGENE SCHWARTZ ASSOCIATES

of the ial that

I try to create copy that leaves a person hanging, copy that has the reader saying, "I've got to get this gratification or I won't be able to sleep."

SOL BLUMENFELD
INDEPENDENT COPYWRITER AND CREATIVE CONSULTANT

me motives : love, gain, ndulgence, tion.

OF FAME

BOARDROOM
SEPT '85
LISTS

U.S. POSTAGE
22

DB DESIGNED BY DAVID BRIER

Mosquitos of RAF strikes at 11a.m. as

Famous last words. The first raid during a Nazi anniversary celebration. The second raid strikes at 4 p.m. as Goebbels takes the rostrum for a pep talk on how well things are going. The meeting is unceremoniously adjourned as spectators flee for cover. **Wooden Wonder.** The Mosquito is a marvel of aeronautical engineering that stings before anyone knows it's there. With a lightweight wooden fuselage and Rolls Royce Merlin engines, it flies like a lightning streak and turns in mid-air on a dime—a handy feature when you discover a swarm of ME-109s on your tail. **Get RAF training and go right into combat.** During the pre-flight briefing, the squadron commander gives you two ways to go: training or missions. Choose training and within seconds you're zooming in and out of the clouds, engaged in a dogfight with enemy ME-109 fighters or JU-88 bombers. That's how you master the feel of the Wooden Wonder and its weaponry. For training outings, your ammunition and fuel are automatically supplied. But for missions, you load your own weapons. The goal: to lay in the right amount of cannon (machine guns) for enemy bombers and fighters, bombs for trains and U-boats, and rockets for the most frightening weapon in the German arsenal, the V-1 Buzz Bomb. During World War II, Mosquitos downed 659 enemy aircraft and 500 V-1 Buzz Bombs. Are you equal to the challenge? **Intelligence reports back you up.** When the intelligence report says "U-boats to strike Allied shipping," or "Enemy train heads for Berlin," you have to act quickly and decisively. You achieve Ace-hood only when you accomplish all missions. **The highest honor.** Your missions will send you after enemy bombers, U-boats, trains and V-1 Buzz Bombs. Select one or any combination. Or choose all four. If you complete the quadruple mission successfully and make it back alive, you become the most distinguished flight veteran of World War II, the Ace of Aces.

Designer: Mark Galarneau
Design Firm: Galarneau & Sinn, Ltd.
Headline Typeface: ITC Bookman Light
Text Typeface: ITC Cheltenham Book
Client: Accolade, Inc.
Usage: Package for software game, "Ace of Aces"

Designer: Saul Bass
Design Firm: The Page Group
Primary Typeface: Helvetica Light
Client: Mohawk Paper Mills
Usage: Trade magazine advertisement insert

Designer: Oswaldo Miranda
Design Firm: Miran Studio
Headline Typeface: ITC Didi ®
Text Typeface: Garamond 49 Italic
Client: *Gráfica* magazine
Usage: Promotional poster

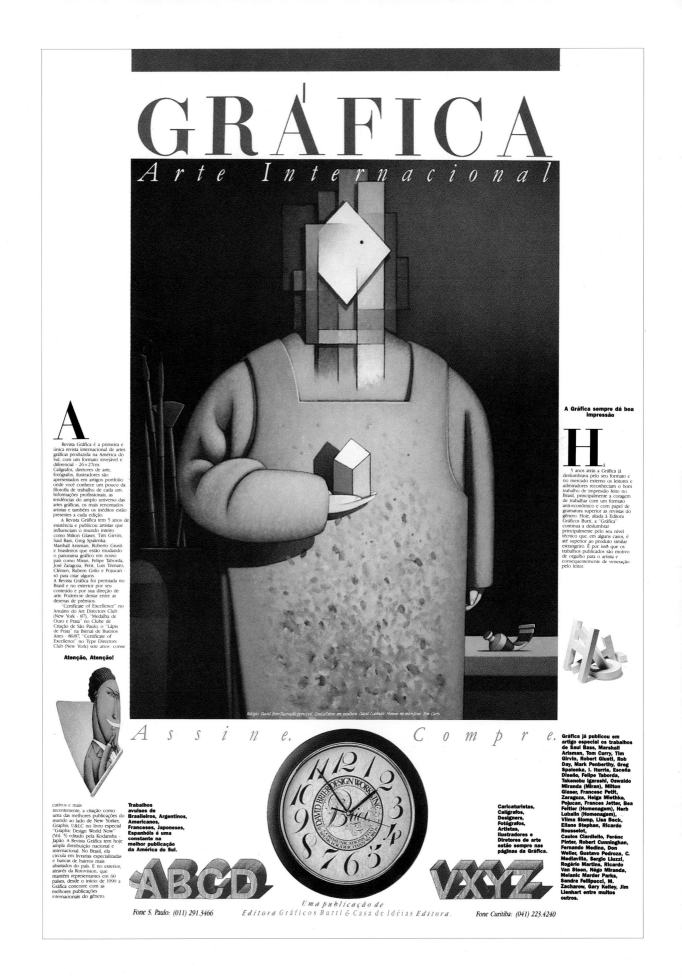

GRÁFICA
Arte Internacional

Relógio: David Brier/Ilustração principal, Caolos/Letras em escultura: David Coleman/ Homem no microfone: Tom Curry

Assine. Compre.

Trabalhos avulsos de Brasileiros, Argentinos, Americanos, Franceses, Japoneses, Espanhóis é uma constante na melhor publicação da América do Sul.

Caricaturistas, Calígrafos, Designers, Fotógrafos, Artistas, Ilustradores e Diretores de arte estão sempre nas páginas da Gráfica.

Uma publicação de
Editora Gráficos Burti & Casa de Idéias Editora.

Fone S. Paulo: (011) 291.3466 Fone Curitiba: (041) 223.4240

Art Director: Duane
 Hammond
Designer: David Roberts
Design Firm: Hammond
 Design Associates
Primary Typeface: News
 Gothic Condensed
Client: Architects Four
Usage: Direct marketing
 brochure and
 presentation folder

Designer: Tim Fisher
Design Firm: Morgan & Company
Primary Typeface: Helvetica Condensed
Client: Panda Group, Inc.
Usage: Logo/Trademark

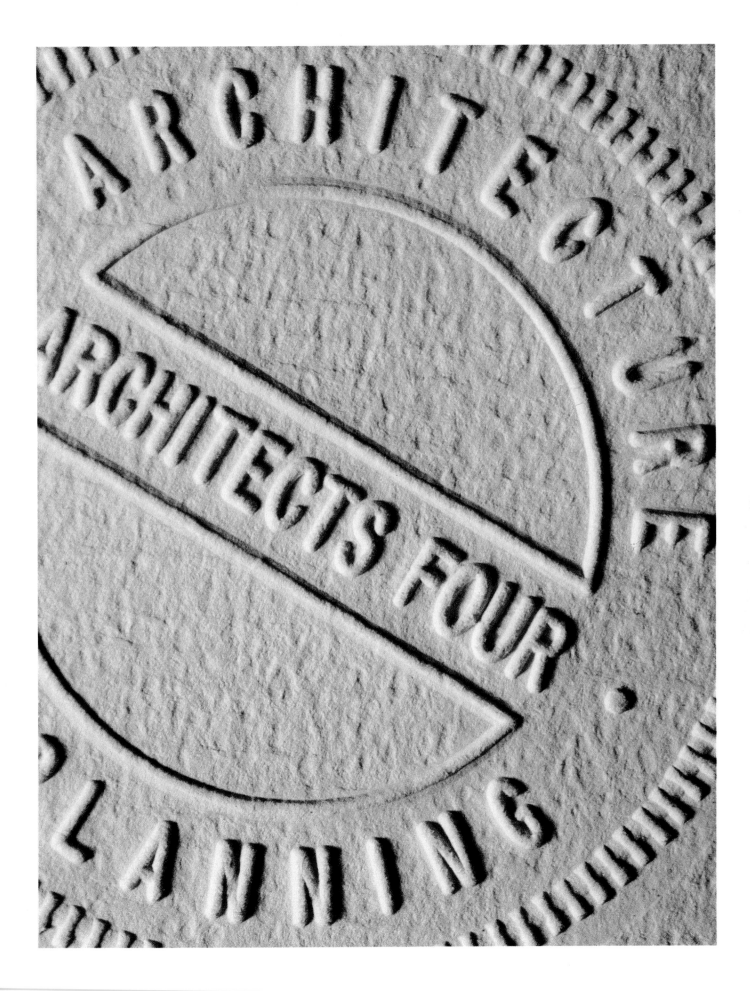

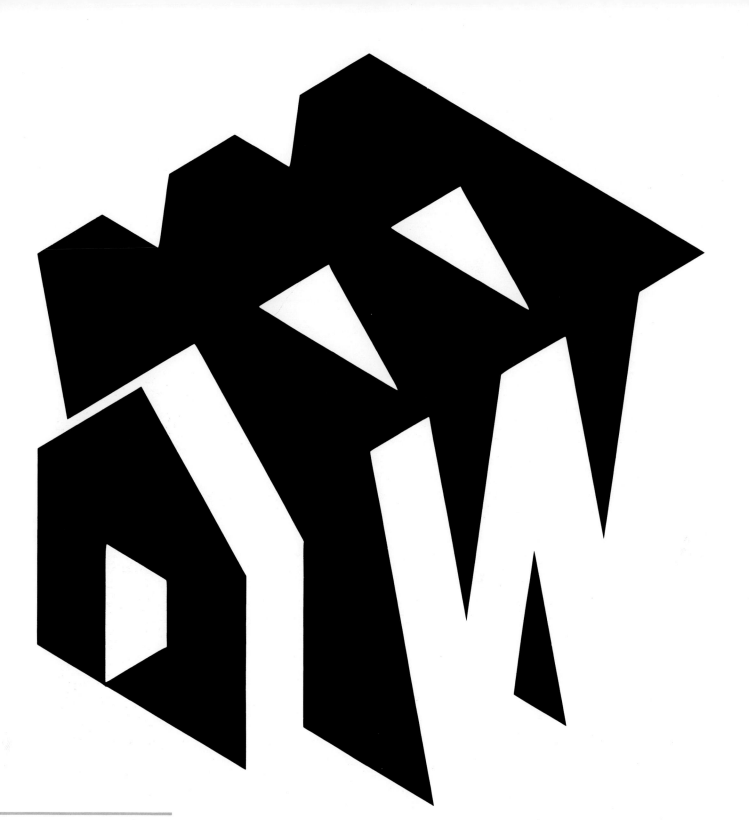

Art Director: Lee Cowell
Designer: Kevin Weinman
Design Firm: Cowell Design Group
Text Typeface: Lubalin Graph
Client: West Construction
Usage: Logo

Designer: Tony Forster
Design Firm: Tony Forster Typographics
Headline Typeface: Various
Client: The Reader's Digest Association Ltd. London
Usage: Book cover

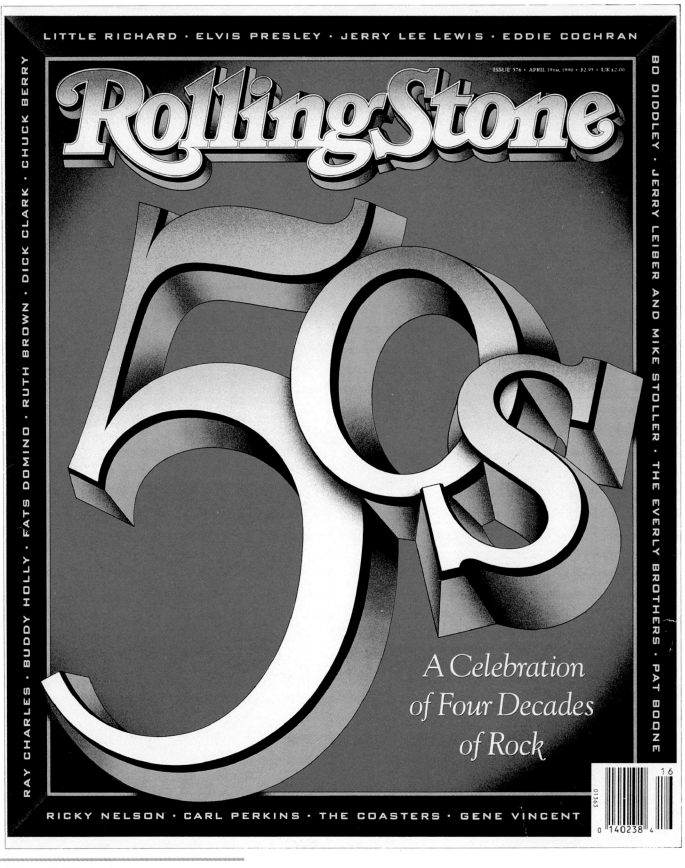

LITTLE RICHARD · ELVIS PRESLEY · JERRY LEE LEWIS · EDDIE COCHRAN

ISSUE 576 · APRIL 19th, 1990 · $2.95 · UK £2.00

RollingStone

50s'

A Celebration of Four Decades of Rock

BO DIDDLEY · JERRY LEIBER AND MIKE STOLLER · THE EVERLY BROTHERS · PAT BOONE

RAY CHARLES · BUDDY HOLLY · FATS DOMINO · RUTH BROWN · DICK CLARK · CHUCK BERRY

RICKY NELSON · CARL PERKINS · THE COASTERS · GENE VINCENT

Designer: Fred Woodward
Design Firm: Rolling Stone
Headline Typeface: Rolling Stone Old Style–Garamond Italic
Client: *Rolling Stone*
Usage: Magazine cover

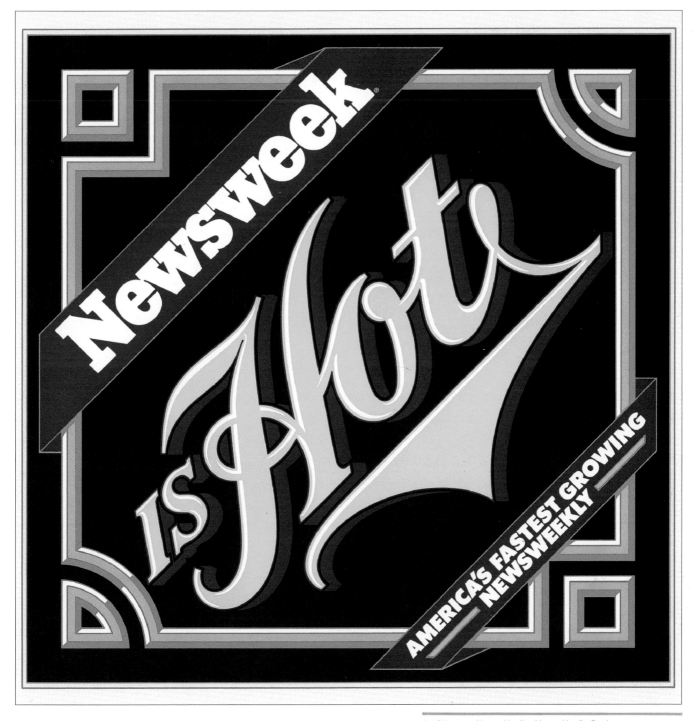

Art Director: Nancy Hoefig, Nancy Hoefig Design
Designer/Letterer: Gerard Huerta
Design Firm: Gerard Huerta Design, Inc.
Headline Typeface: Hand-lettered
Text Typeface: Futura Extra Bold
Client: *Newsweek*
Usage: Direct mail promotion

TYPE THAT BEAUTIFIES A DESIGN

Typography can not only enhance the message but be beautiful in and of itself. While this is sometimes simply a reflection of the product or service, at other times beautiful type brings an extra, special quality to a design solution—or becomes the design or message itself.

Inherently beautiful letterforms can be created with hand-lettered or hand-rendered type or calligraphy. This decorative approach graces the work of such superb letterers as Tony DiSpigna, Gerard Huerta and John Stevens.

In other cases, traditional typefaces are used so well and with such care that they enhance a piece. Futura and Benguiat are miles apart typographically, but in the hands of Jennifer Morla and Ed Benguiat each becomes a thing of beauty.

Finally the combination of type and images produces exquisite results as shown in Michael Brock's work for *LA Style*, Tom Carnase's "Tin Can Typography" poster, or Bruce Hale's poster for Mainly Mozart at Meany, where stunning script is combined with a classically inspired illustration depicting the composer.

Many other examples in this section combine one or more of the above approaches, showing the infinite possibilities you can achieve.

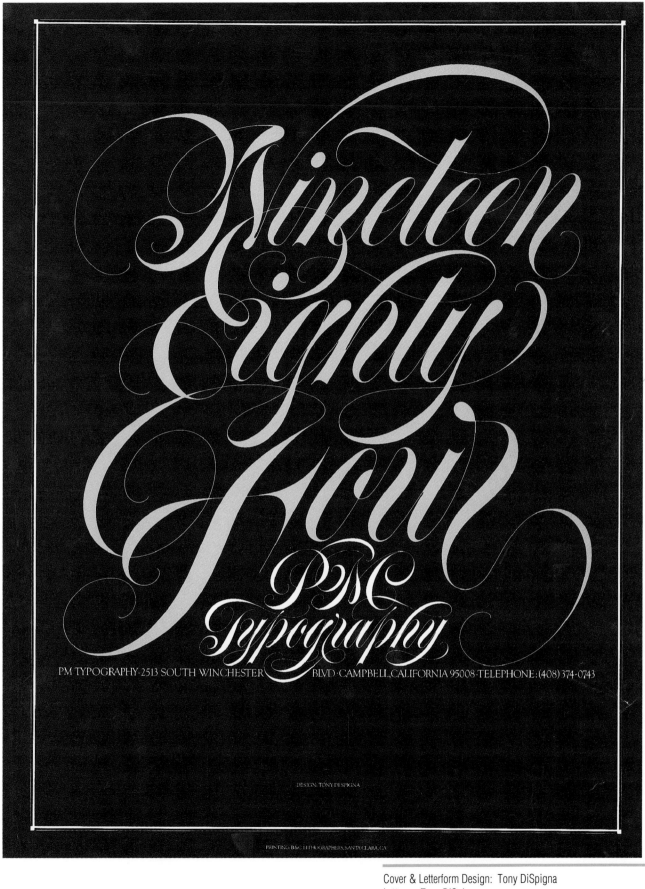

Cover & Letterform Design: Tony DiSpigna
Letterer: Tony DiSpigna
Design Firm: Tony DiSpigna, Inc.
Headline Typeface: Hand-lettered
Client: PM Typography
Usage: Promotional calendar

Designer: Fred Woodward
Design Firm: Rolling Stone
Headline Typeface: Goudy
 Forum
Client: *Rolling Stone*
Usage: Page from magazine
 spread

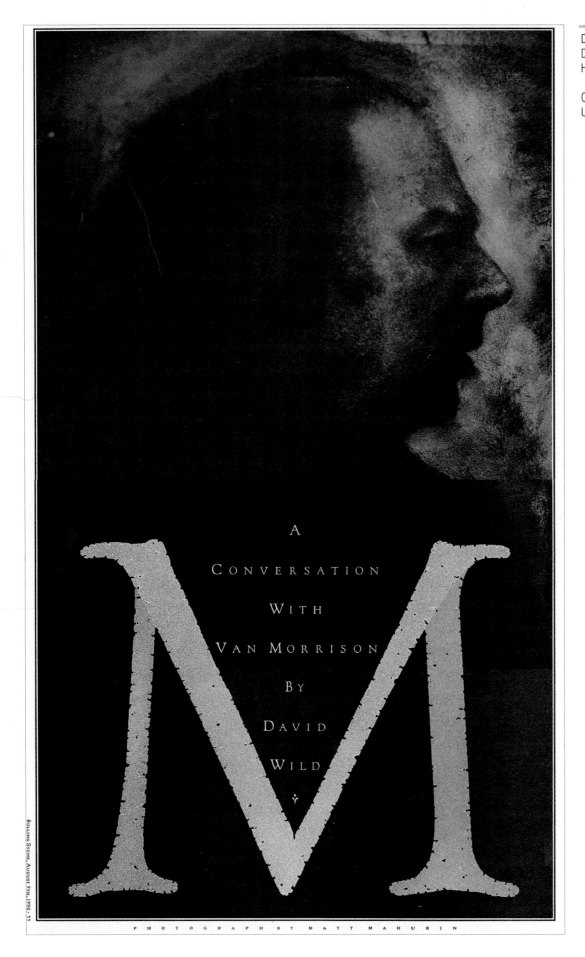

A

CONVERSATION

WITH

VAN MORRISON

BY

DAVID

WILD

PHOTOGRAPH BY MATT MAHURIN

ROLLING STONE, AUGUST 9TH, 1990 · 55

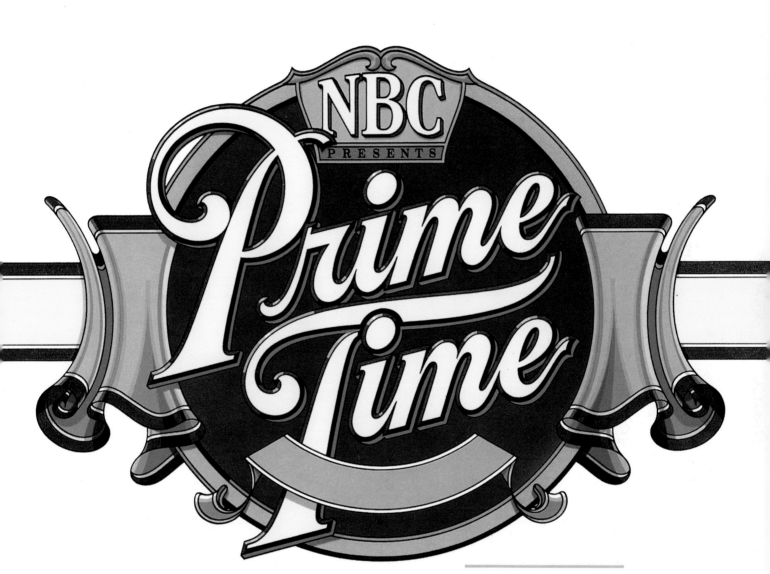

Art Director: Vasken Kalayjian, NBC
Designer/Letterer: Gerard Huerta
Design Firm: Gerard Huerta Design, Inc.
Headline Typeface: Hand-rendered
Client: NBC
Usage: Promotion

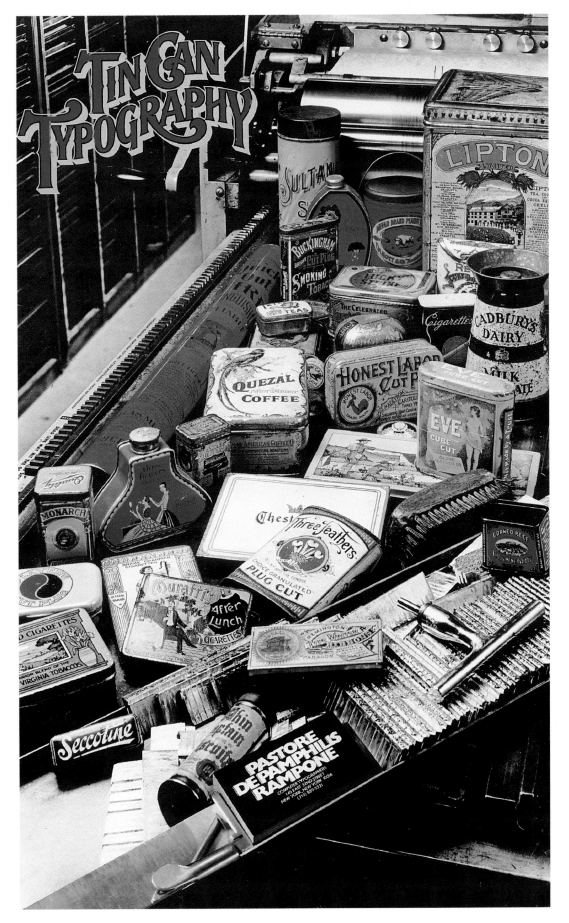

Designer: Tom Carnase
Letterer: Tom Carnase
Design Firm: Carnase, Inc.
Headline Typeface: Hand-
 rendered
Client: World Typeface
 Center, Inc.
Usage: Poster

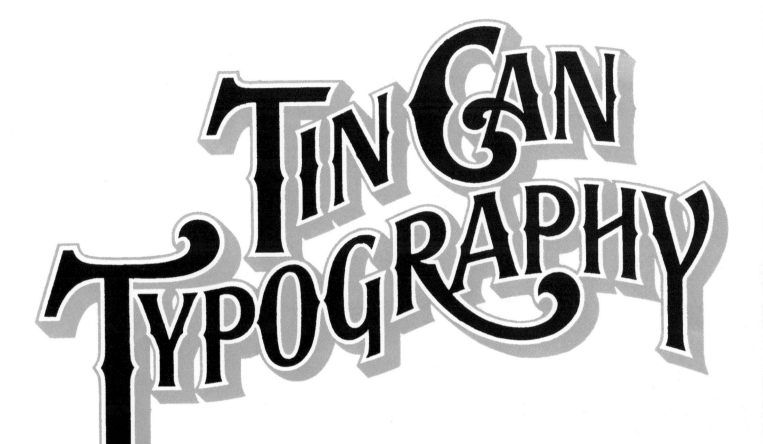

The way this inspired type
treatment captures and
recreates the feeling of an era
is the tickler here. Note the
beautiful use of swashes and
how they are not overdone.

Designers: Jennifer Morla and Mariann Mitten
Design Firm: Morla Design, Inc.
Headline Typeface: Futura Inline, Futura Book
Text Typeface: Futura Extra Bold, Futura Bold
 Condensed
Client: Mercury Typography
Usage: Poster

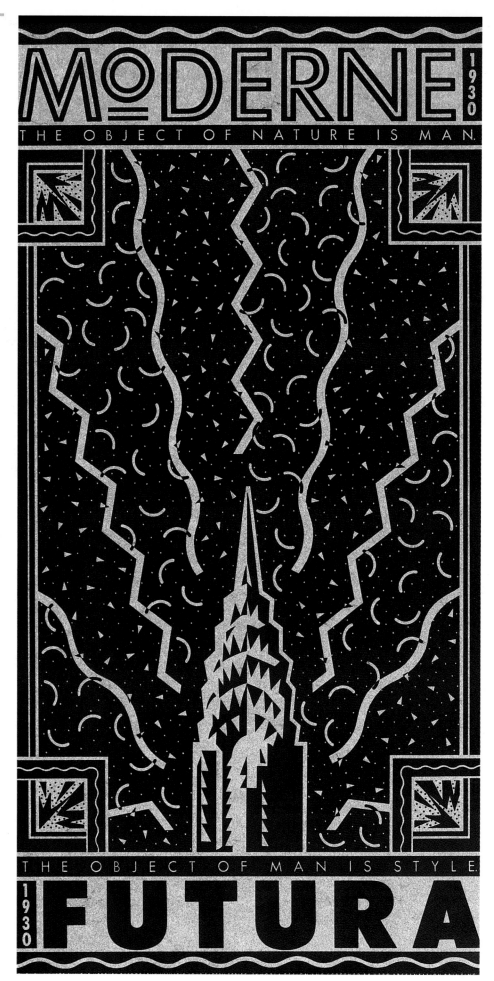

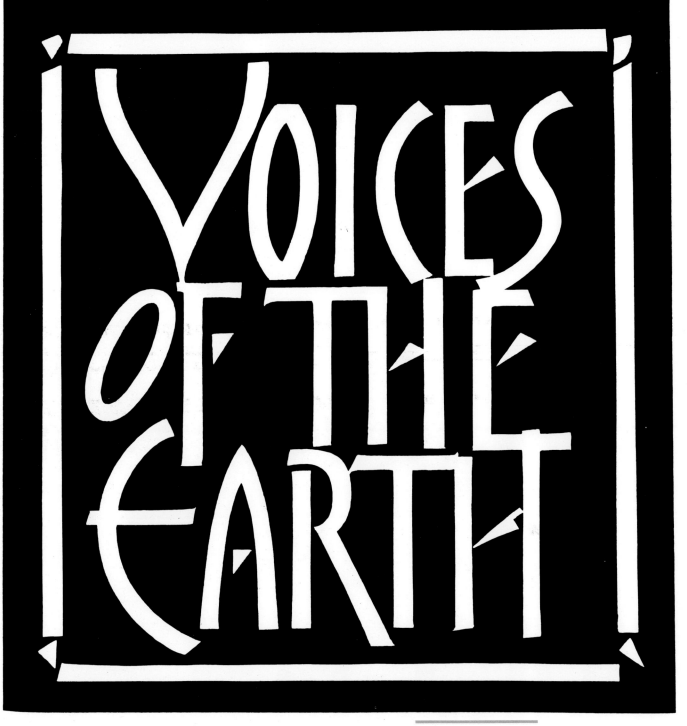

Designer: John Stevens
Letterer: John Stevens
Design Firm: John Stevens
 Design
Headline Typeface:
 Hand-lettered
Client: Vital Body
Usage: Cassette packaging

Designer: Herb Lubalin, Editorial and Design Director
Letterer: Tom Carnase
Design Firm: International Typeface Corporation (ITC)
Headline Typeface: ITC Didi ®
Client: *Upper & Lower Case* magazine (published by ITC)
Usage: Magazine editorial spread

Our
best
wishes
for a
beautiful
newyear

THIS ARTICLE WAS SET IN ITC DIDI (HAND-TAILORED)

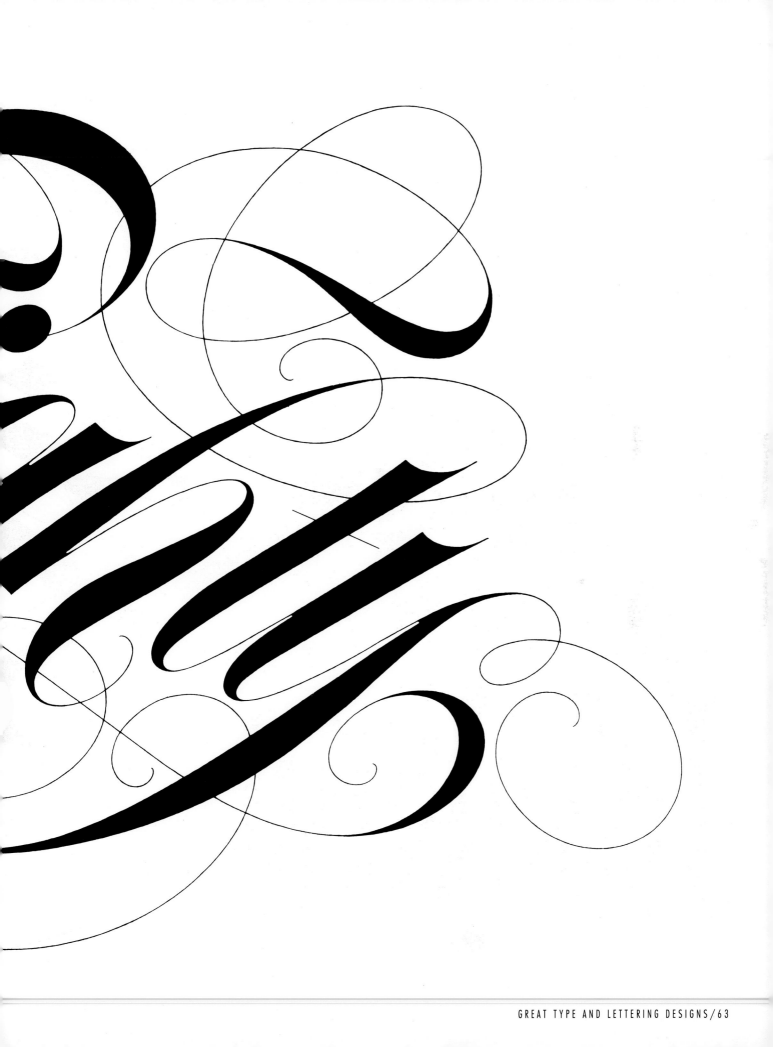

JULIAN WATERS LETTERFORMS

Hand Lettering, Calligraphy & Design 9509 Aspenwood Place, Gaithersburg, Maryland 20850

To:

Designer: Julian Waters
Letterer: Julian Waters
Design Firm: Julian Waters Letterforms
Headline Typeface: Hand-lettered
Text Typeface: Adobe Garamond
Client: Julian Waters Letterforms
Usage: Envelope for seasons greeting/self-promotion

The greatest challenge in creating two letters with the grace of a pair of dancers is first realizing this opportunity exists. Then comes exploring the various possible swashes, rhythms and positions to achieve that goal. Ultimately, the brilliance of this piece lies in its celebration of these two letters on this simple page.

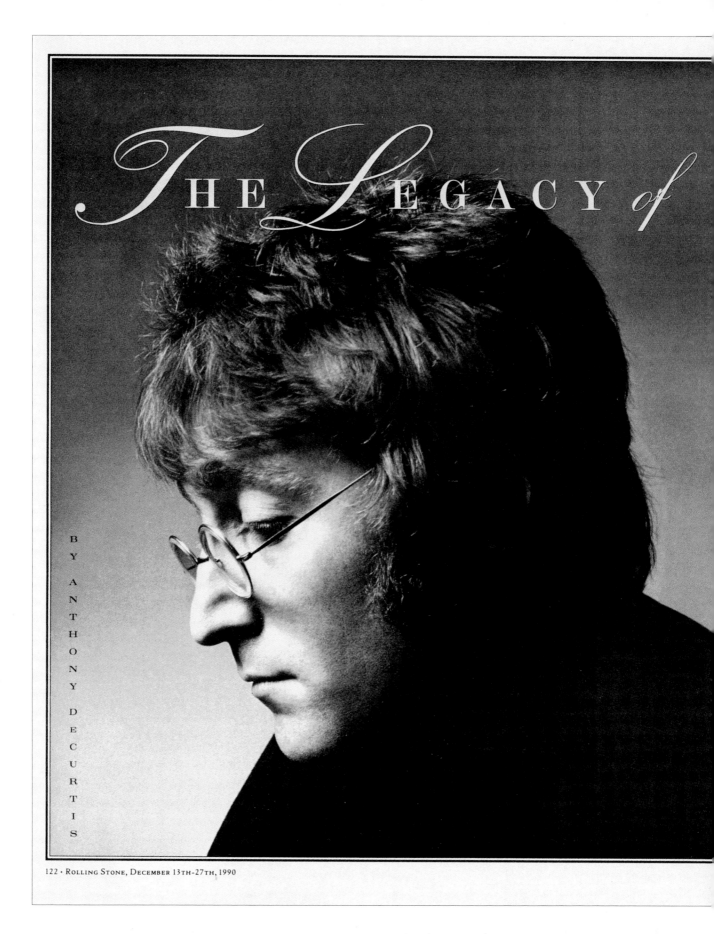

THE LEGACY of

BY ANTHONY DECURTIS

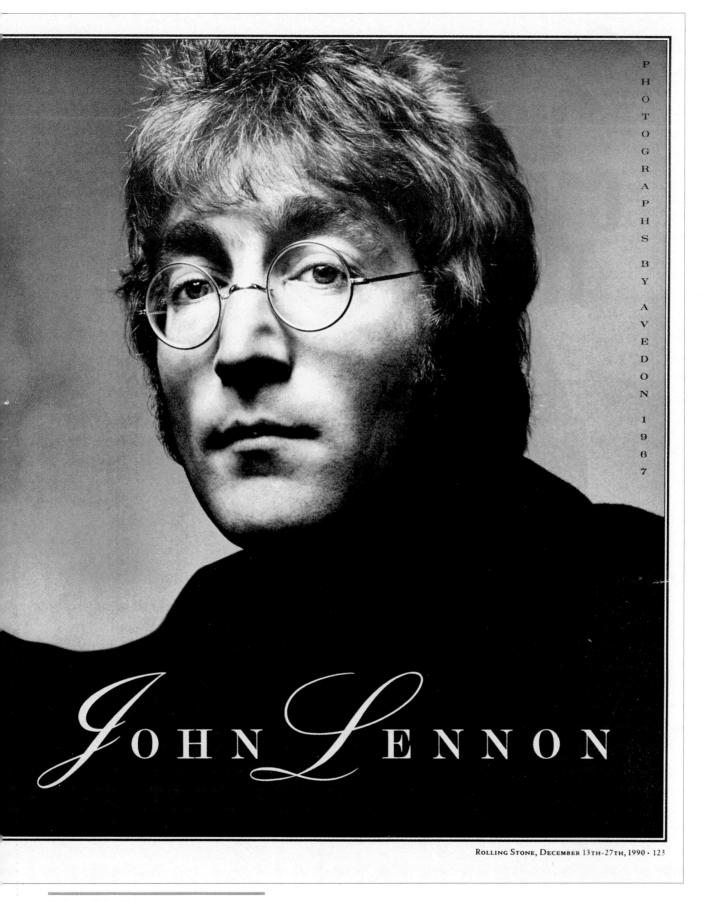

John Lennon

ROLLING STONE, DECEMBER 13TH-27TH, 1990 · 123

Designer: Debra Bishop
Design Firm: Rolling Stone
Headline Typeface: Modern #20 with Excelsior Script
Client: *Rolling Stone*
Usage: Spread from magazine article

JOHN LENNON: THE MAN

*O*ctober 9th marked the fiftieth anniversary of John Lennon's birth. December 8th will mark the tenth anniversary of his death. It is somehow fitting that the two dates will proceed forever down the ages, each inspiring commemoration as they simultaneously reach round numbers, the sad

Designer: Debra Bishop
Letterer: Jeannie Greco
Design Firm: Rolling Stone
Headline Typeface: Modern #20 with Excelsior Script
Client: *Rolling Stone*
Usage: Opening page of magazine article

Art Director: Kit Hinrichs
Designer: Susan Tsuchiya
Design Firm: Pentagram Design
Photographer: Barry Robinson
Headline Typeface: Bauer Bodoni (Mergenthaler system), Snell
 Roundhand, Century Nova (rubber stamp)
Text Typeface: Granjon, Roman and Italic (Linotype); Initial
 caps—Commercial Script (American Type Founder's
 Foundry Type); and Garamont (Monotype)
Client: Craig W. Johnson's Country Matters
Usage: Promotional portfolio of antique garden statuary

Art Director: Susan Lyster Armstrong,
 McCaffrey & McCall Advertising
Designer/Letterer: Gerard Huerta
Design Firm: Gerard Huerta Design, Inc.
Primary Typeface: Hand-lettered
Client: Exxon
Usage: Television program title

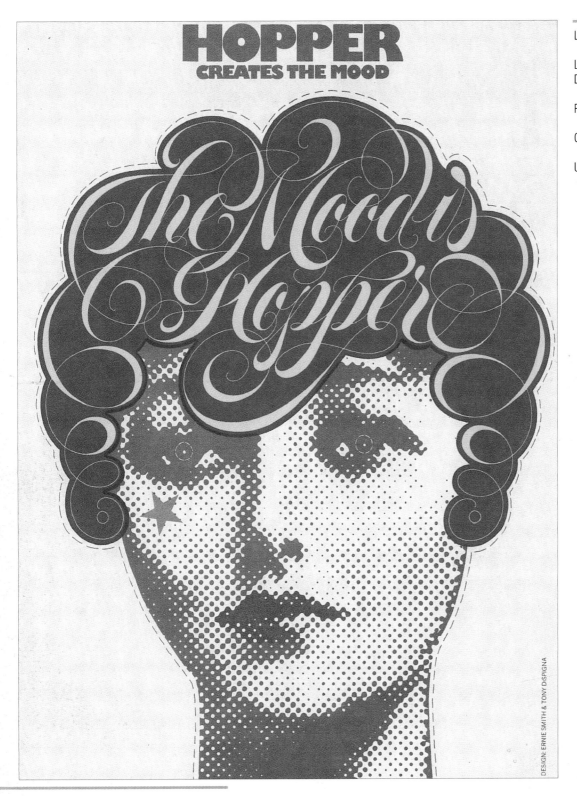

HOPPER
CREATES THE MOOD

The Mood is Hopper

DESIGN: ERNIE SMITH & TONY DiSPIGNA

Letterform Designer: Tony DiSpigna
Letterer: Tony DiSpigna
Design Firm: Tony DiSpigna, Inc.
Primary Typeface: Hand-lettered
Client: Container Corporation of America
Usage: Promotional poster for the Master Series

Designer: Ernie Smith/Tony DiSpigna
Letterer: Tony DiSpigna
Design Firm: Tony DiSpigna, Inc.
Headline Typeface: Hand-lettered
Text Typeface: Poster
Client: Hopper Papers, a Division of Georgia Pacific
Usage: Paper promotion

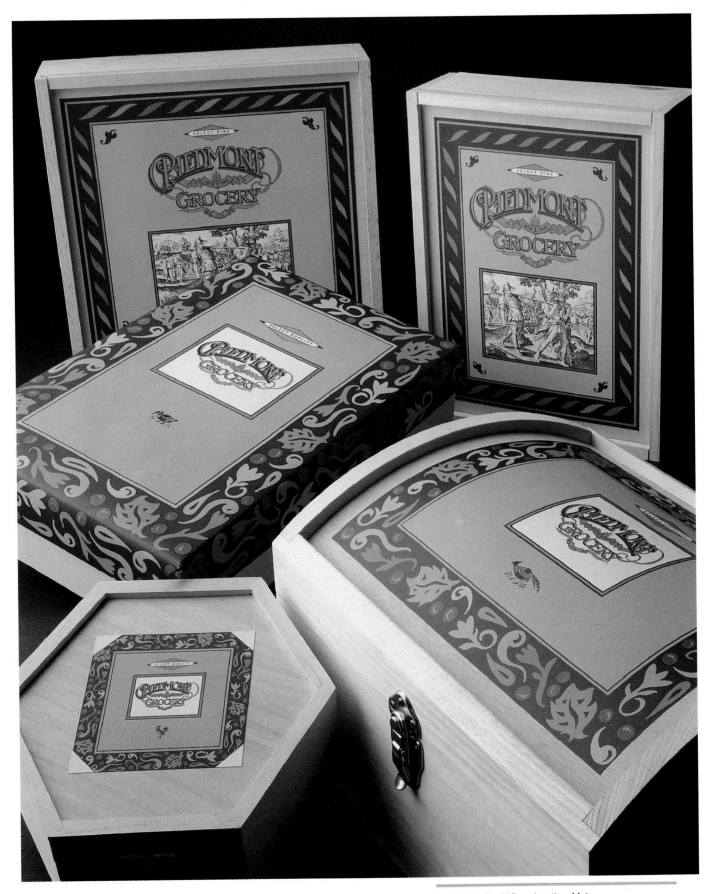

Designers: David Poe, Jonathan Mulcare
Design Firm: Emery/Poe Design
Headline Typeface: Custom
Text Typeface: Custom
Client: Piedmont Grocery
Usage: Gift packaging program for specialty food company

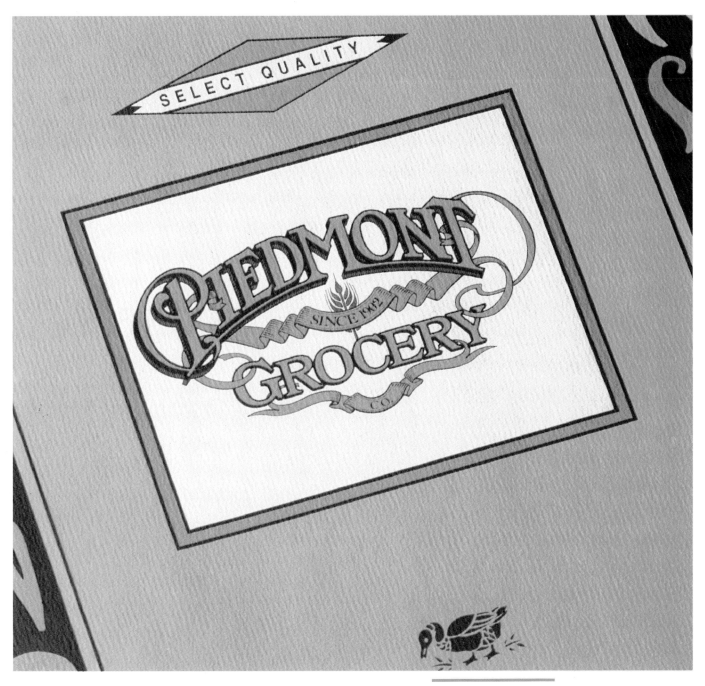

This identity has all the personality of an old-time general store. The arched type and typographic adornments convey an innocent appeal that is, at once, universal.

Designer: Tony Forster
Letterer: Tony Forster
Design Firm: Tony Forster Typographics
Headline Typeface: Hand-rendered
Client: Willow House Gallery
Usage: Stationery, carrier bags, signs, etc.

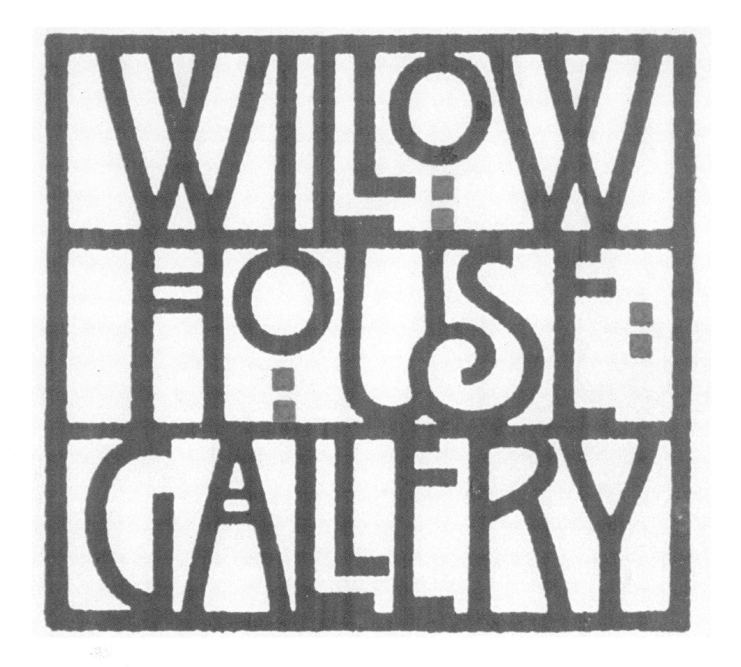

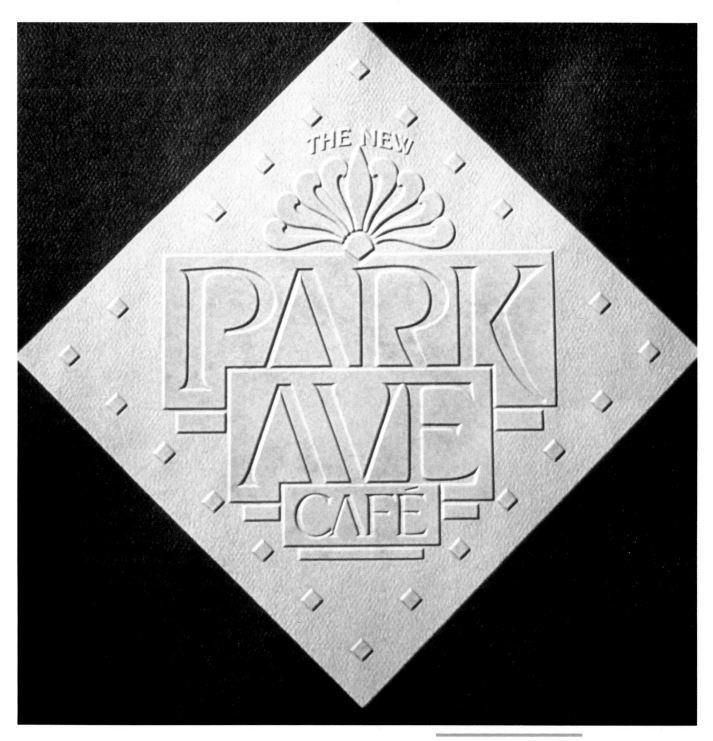

Designer: David Brier
Letterer: David Brier
Design Firm: DBD International, Ltd.
Headline Typeface: Hand-drawn
Text Typeface: Hand-drawn
Client: Park Ave Cafe
Usage: Menu cover design

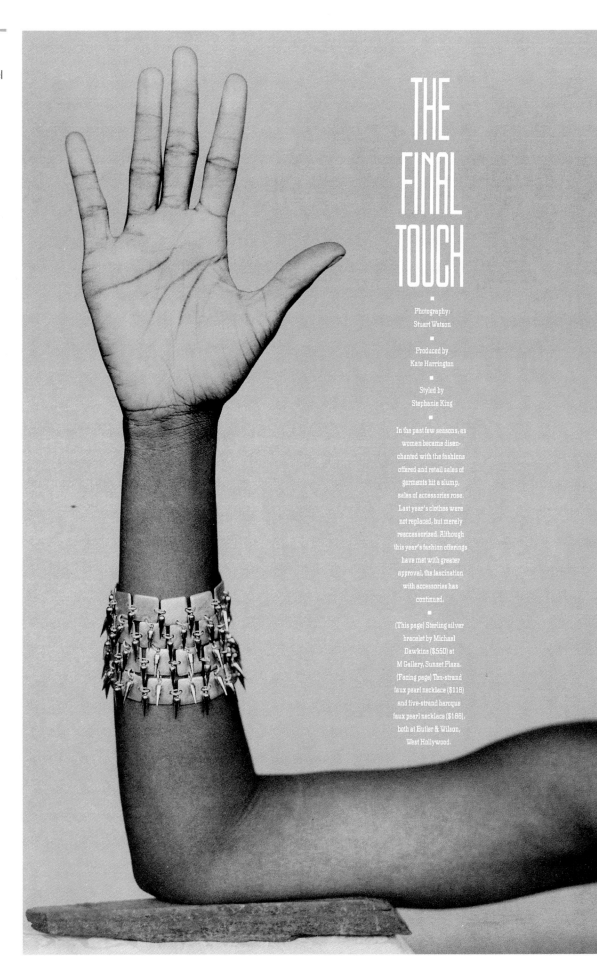

Designer: Michael
 Brock
Design Firm: Michael
 Brock Design
Headline Typeface:
 LA Style No. 1
Text Typeface:
 Geometric Bold
 Condensed
Client: *LA Style*
Usage: Magazine
 fashion spread

THE FINAL TOUCH

Photography:
Stuart Watson

Produced by
Kate Harrington

Styled by
Stephanie King

In the past few seasons, as women became disenchanted with the fashions offered and retail sales of garments hit a slump, sales of accessories rose. Last year's clothes were not replaced, but merely reaccessorized. Although this year's fashion offerings have met with greater approval, the fascination with accessories has continued.

(This page) Sterling silver bracelet by Michael Dawkins ($550) at M Gallery, Sunset Plaza. (Facing page) Ten-strand faux pearl necklace ($118) and five-strand baroque faux pearl necklace ($186), both at Butler & Wilson, West Hollywood.

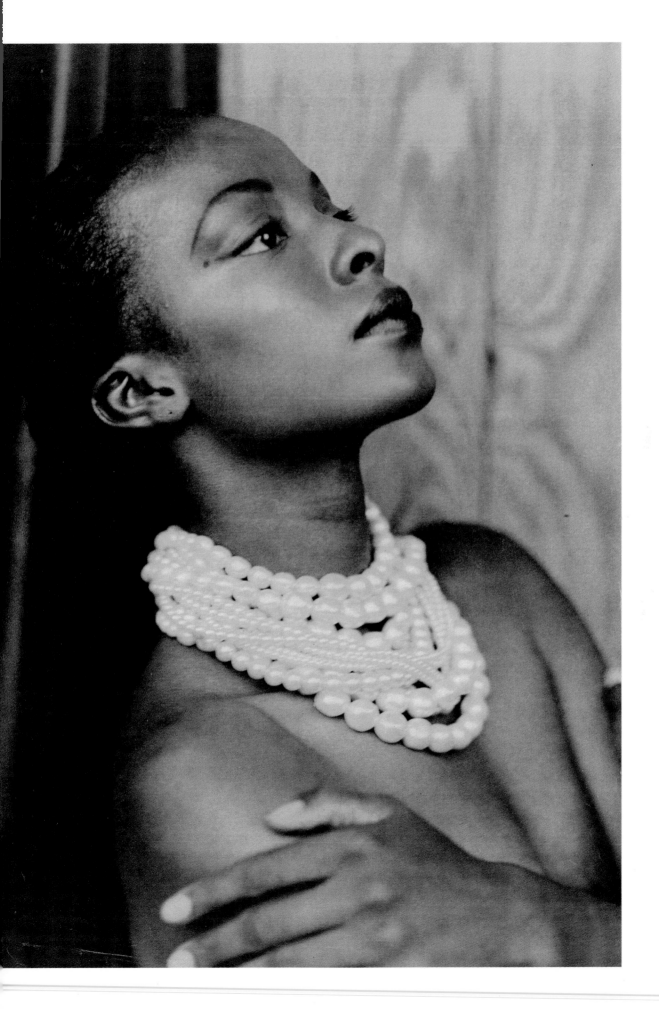

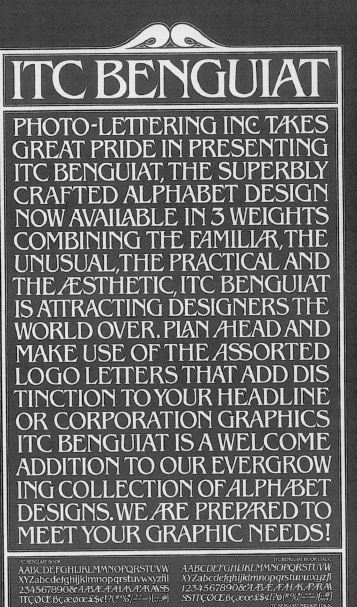

Designer: Ed Benguiat
Design Firm: Photo-lettering, Inc.
Headline Typeface: ITC Benguiat
Text Typeface: ITC Benguiat
Client: Photo-lettering, Inc.
Usage: Poster

Ed Benguiat introduced his new typeface to the world with this poster. Note the skillful use of ligatures and the even type color throughout, which was created through the consistent letterspacing.

ABLE IN 3 WEIG
G THE FAMILIAR,
THE PRACTICAL,
ETIC, ITC BENGU
NG DESIGNERS
ER. PLAN AHEAD
OF THE ASSORT
TERS THAT ADD
TO YOUR HEADL
ORATION GRAPH

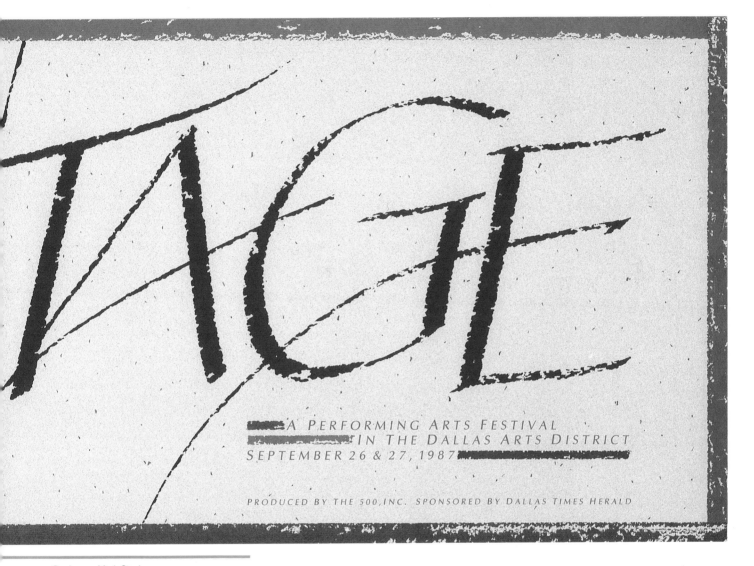

Designer: Mark Steele
Letterer: Mark Steele
Design Firm: Design Studio of Steele Presson
Headline Typeface: Hand-rendered
Text Typeface: CG Omega (modified)
Client: The 500, Inc.
Usage: Poster

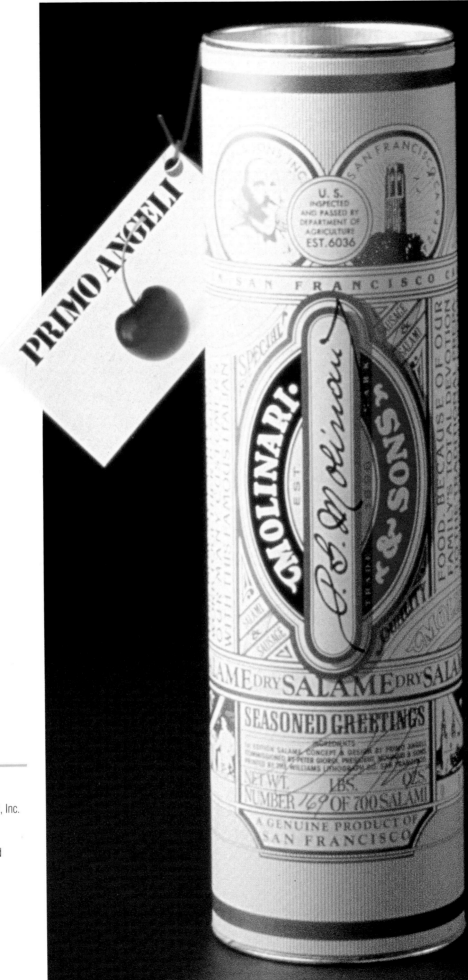

Designer: Primo Angeli
Letterer: Primo Angeli
Design Firm: Primo Angeli, Inc.
Headline Typeface: Hand-
 rendered
Text Typeface: Korinna and
 Windsor Outline
Client: Molinari & Sons
Usage: Label

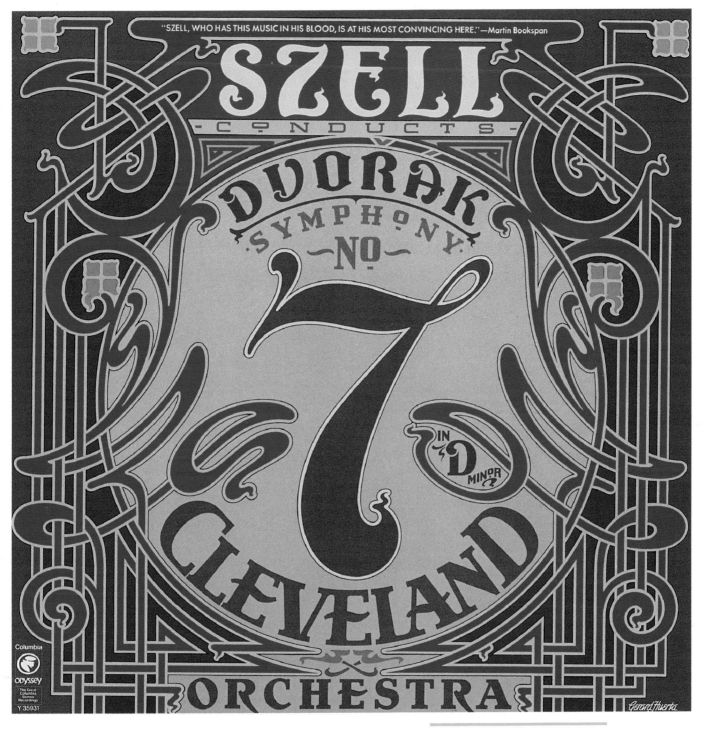

Art Director: John Berg, CBS Records
Designer/Letterer: Gerard Huerta
Design Firm: Gerard Huerta Design, Inc.
Primary Typeface: Hand-lettered
Client: Columbia/Odyssey
Usage: Album cover

361
DESIGN
GROUP

Designer: John Stevens
Letterer: John Stevens
Design Firm: John Stevens Design
Primary Typeface: Hand-rendered
Client: 361 Design Group
Usage: Logo

Designer: Daniel Pelavin
Letterer: Daniel Pelavin
Design Firm: Daniel Pelavin
Headline Typeface: Hand-
 rendered
Text Typeface: Hand-
 rendered
Client: Smithsonian Institute
 Traveling Exhibition
Usage: Poster to accompany
 traveling exhibition

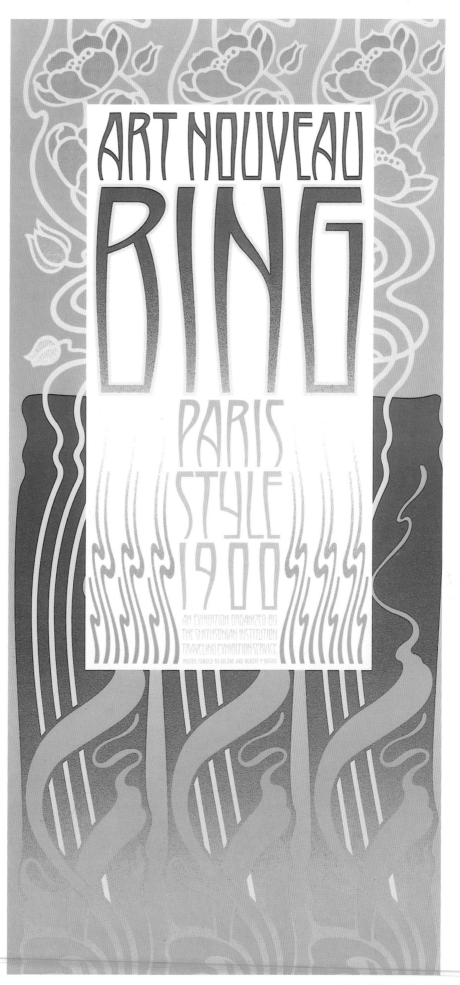

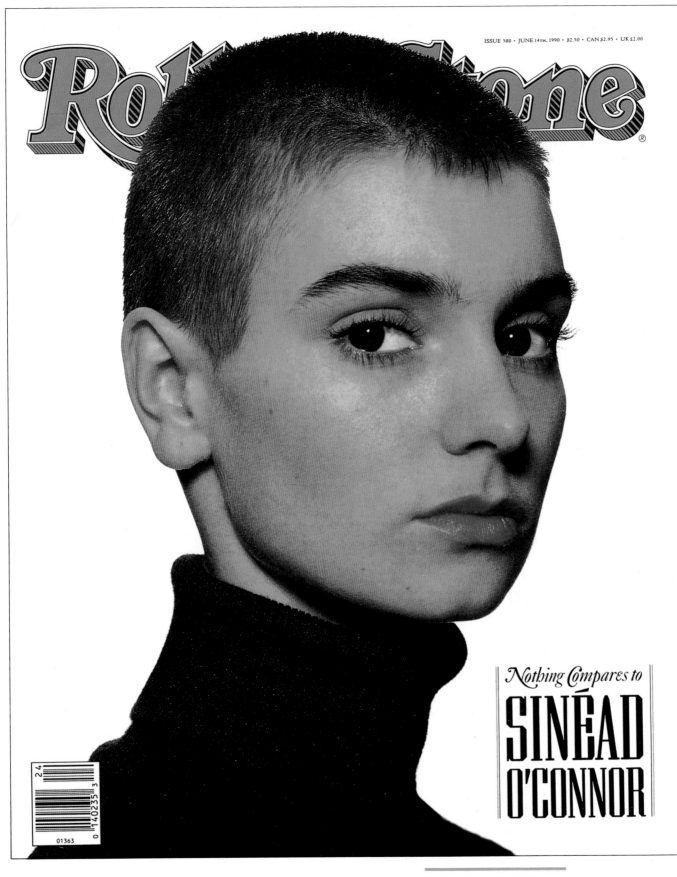

ISSUE 580 • JUNE 14TH, 1990 • $2.50 • CAN $2.95 • UK £2.00

Nothing Compares to
SINÉAD O'CONNOR

Designer: Fred Woodward
Letterer: Dennis Ortiz-Lopez
Design Firm: Rolling Stone
Headline Typeface: Hand-lettered
Text Typeface: Garamond 49 italic
Client: *Rolling Stone*
Usage: Magazine cover

Designer: Skip Johnston
Design Firm: Skip Johnston
Headline Typeface:
 Woodtype
Text Typeface: Various
Client: P.E.N.
Usage: Meeting
 announcement

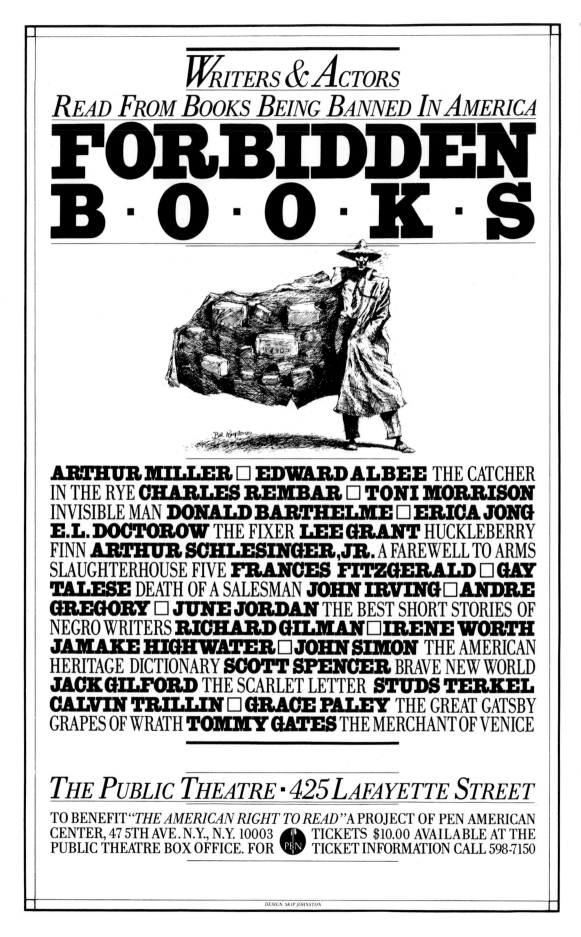

WRITERS & ACTORS
READ FROM BOOKS BEING BANNED IN AMERICA

FORBIDDEN
B·O·O·K·S

ARTHUR MILLER □ EDWARD ALBEE THE CATCHER IN THE RYE CHARLES REMBAR □ TONI MORRISON INVISIBLE MAN DONALD BARTHELME □ ERICA JONG E.L. DOCTOROW THE FIXER LEE GRANT HUCKLEBERRY FINN ARTHUR SCHLESINGER, JR. A FAREWELL TO ARMS SLAUGHTERHOUSE FIVE FRANCES FITZGERALD □ GAY TALESE DEATH OF A SALESMAN JOHN IRVING □ ANDRE GREGORY □ JUNE JORDAN THE BEST SHORT STORIES OF NEGRO WRITERS RICHARD GILMAN □ IRENE WORTH JAMAKE HIGHWATER □ JOHN SIMON THE AMERICAN HERITAGE DICTIONARY SCOTT SPENCER BRAVE NEW WORLD JACK GILFORD THE SCARLET LETTER STUDS TERKEL CALVIN TRILLIN □ GRACE PALEY THE GREAT GATSBY GRAPES OF WRATH TOMMY GATES THE MERCHANT OF VENICE

THE PUBLIC THEATRE · 425 LAFAYETTE STREET

TO BENEFIT *"THE AMERICAN RIGHT TO READ"* A PROJECT OF PEN AMERICAN CENTER, 47 5TH AVE. N.Y., N.Y. 10003 ● PEN TICKETS $10.00 AVAILABLE AT THE PUBLIC THEATRE BOX OFFICE. FOR TICKET INFORMATION CALL 598-7150

DESIGN: SKIP JOHNSTON

Waterways

Designer: Julian Waters
Letterer: Julian Waters
Design Firm: Julian Waters Letterforms
Headline Typeface: Hand-lettered
Client: Waterways Calendar
Usage: Wall calendar logo

Pushpin Lubalin Peckolick

Designer: Alan Peckolick
Letterer: Tony DiSpigna
Design Firm: Pushpin Lubalin Peckolick
Headline Typeface: Hand-lettered
Client: Pushpin Lubalin Peckolick
Usage: Corporate logo

Letterform Designer: Tony DiSpigna
Letterer: Tony DiSpigna
Design Firm: Tony DiSpigna, Inc.
Primary Typeface: Hand-lettered
Client: Jason and Janet Calfo
Usage: Wedding invitation

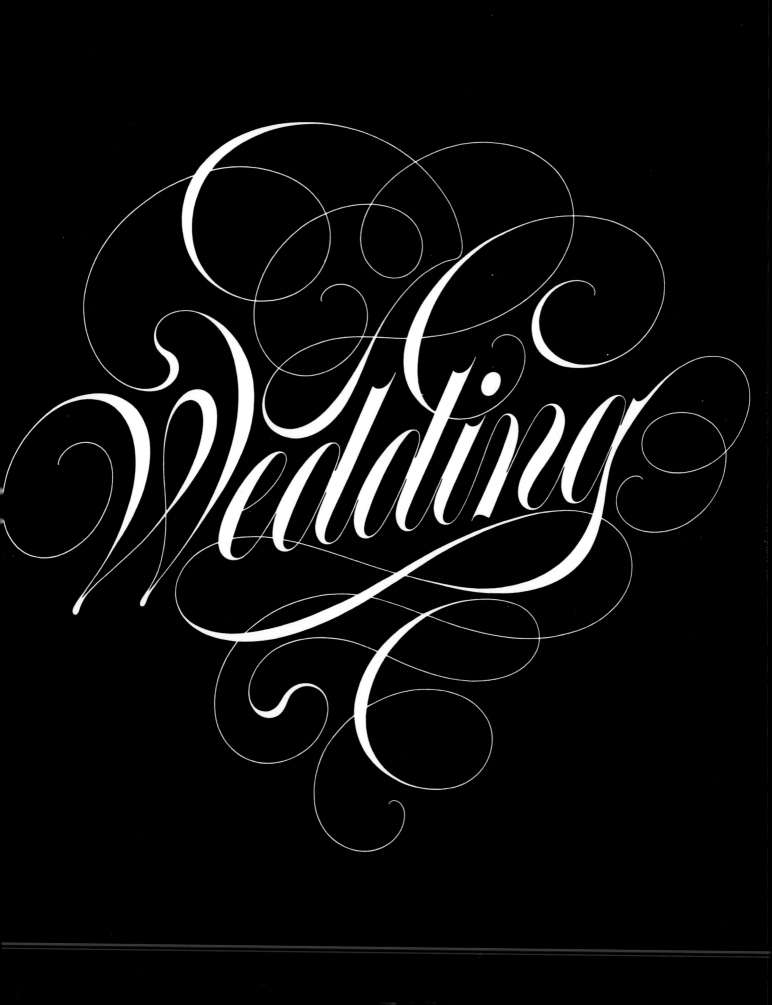

Designer: Todd Nesser
Design Firm: McCool & Company
Headline Typeface: Oakland 15
Text Typeface: Trump Mediaeval
Client: Weyerhaeuser Company
Usage: Sales material, packaging, point of purchase

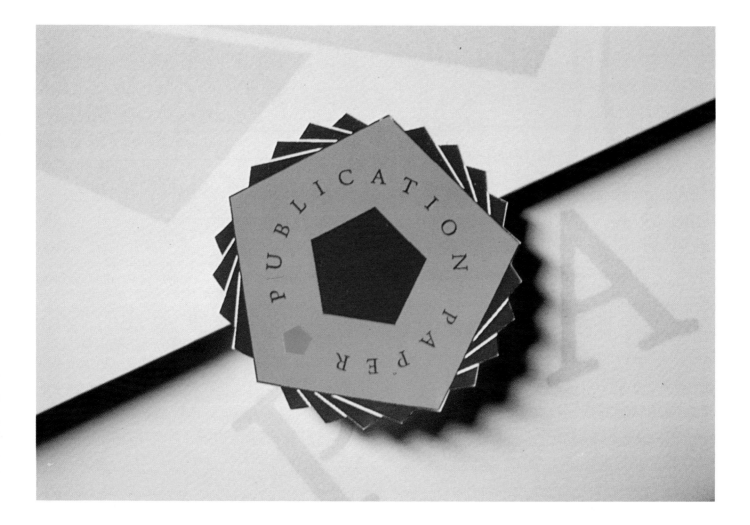

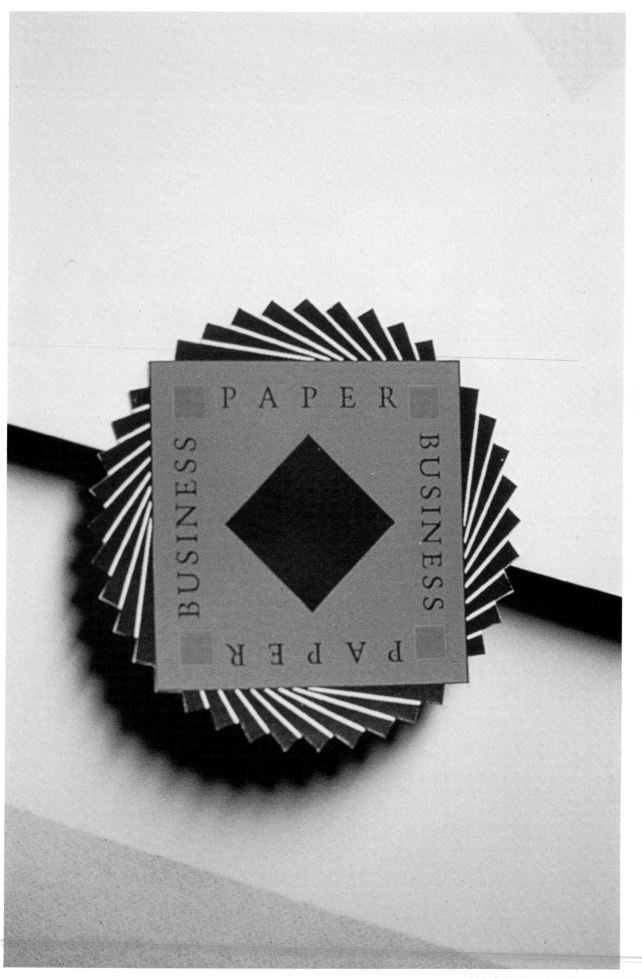

Oxford

CITY COUNCIL

Designer: Tony Forster
Letterer: Tony Forster
Design Firm: Tony Forster Typographics
Headline Typeface: Hand-rendered
Text Typeface: Berthold, Caslon Bush Caps
Client: Oxford City Council
Usage: All printed material

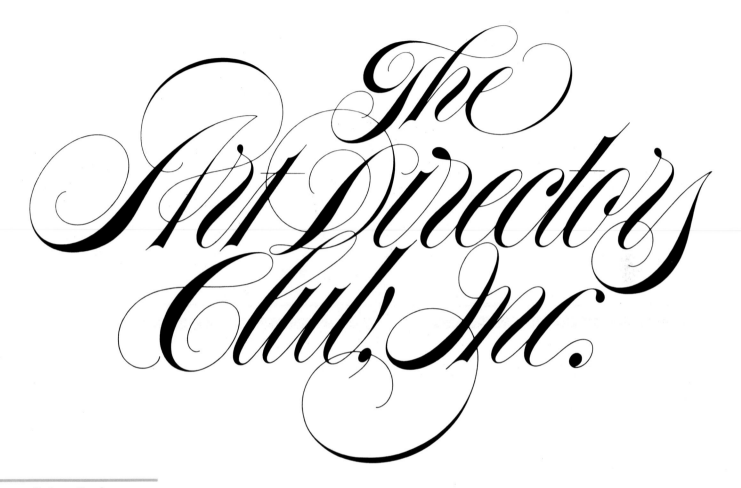

Designer: Tom Carnase
Letterer: Tom Carnase
Design Firm: Carnase, Inc.
Headline Typeface: Hand-
 lettered
Client: New York Art
 Directors Club
Usage: Logo

Designer: David Brier
Letterer: David Brier
Design Firm: DBD International, Ltd.
Headline Typeface: ITC Bookman & hand lettering
Text Typeface: ITC Bookman
Client: Graphic Relief
Usage: Spread in promotion

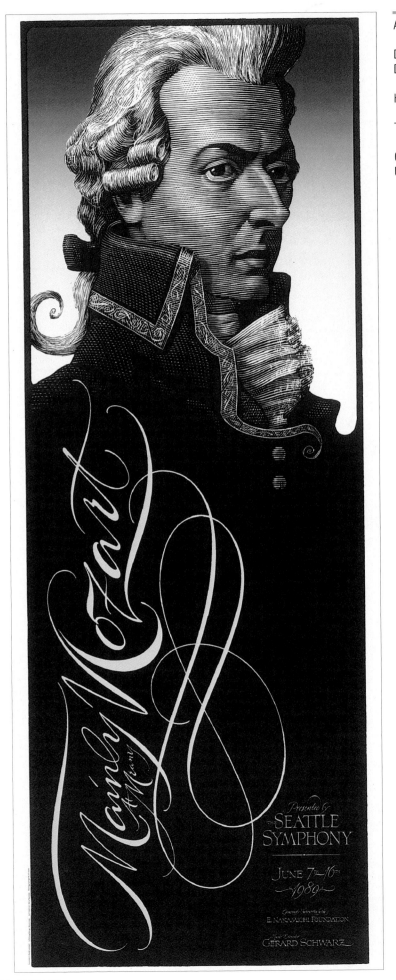

Art Director: Mary Macenka,
 Seattle Symphony
Designer/Letterer: Bruce Hale
Design Firm: Bruce Hale
 Design Studio
Headline Typeface:
 Calligraphy
Text Typeface: Hand-
 rendered
Client: Seattle Symphony
Usage: Promotion

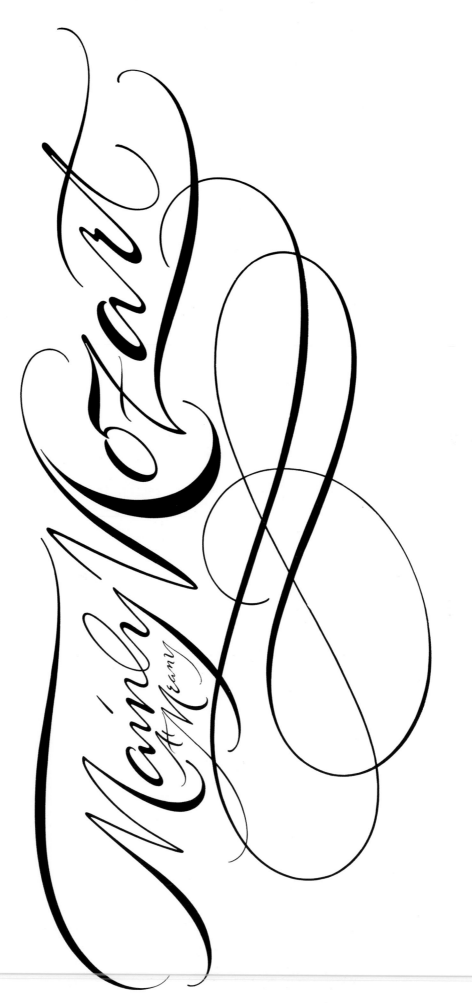

This piece has a grace and rhythm rarely captured in posters. Note how the down-stroke of the y in Mainly forms the upstroke of the M in Mozart.

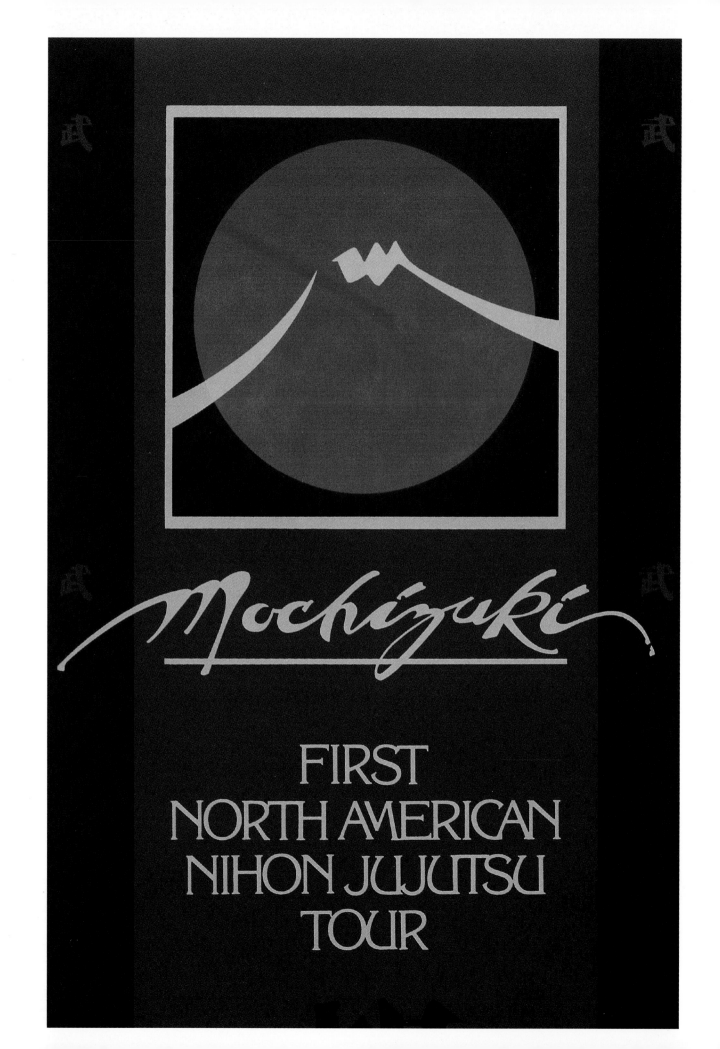

Mochizuki

FIRST
NORTH AMERICAN
NIHON JUJUTSU
TOUR

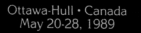

Ottawa-Hull • Canada
May 20-28, 1989

Birmingham, Alabama • U.S.A.
June 3-4, 1989

Mission Viejo, California • U.S.A.
June 9-11, 1989

Designer: Terry Laurenzio
Letterer: Terry Laurenzio
Design Firm: 246 Fifth Design Associates
Headline Typeface: Hand-lettered
Text Typeface: Korinna
Client: Yōseikan Bōdo Association
Usage: Poster

Designer: Alan Peckolick
Design Firm: Lubalin Peckolick
Headline Typeface: Lettera Gothic
Client: Mobil Corporation
Usage: Bus shelter poster

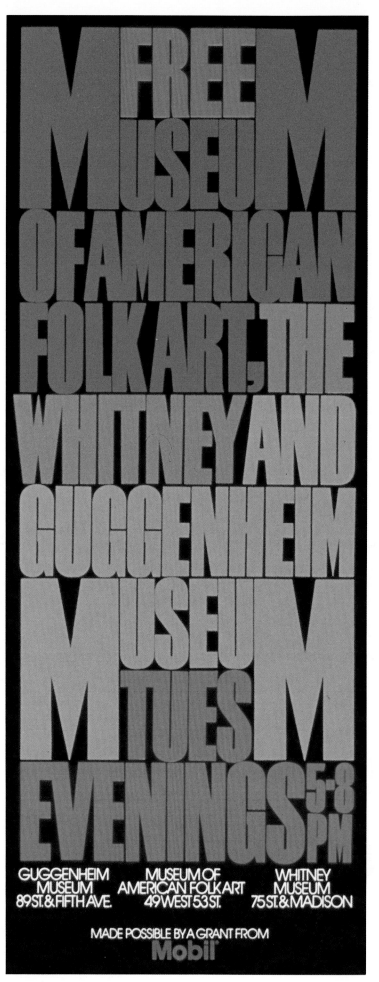

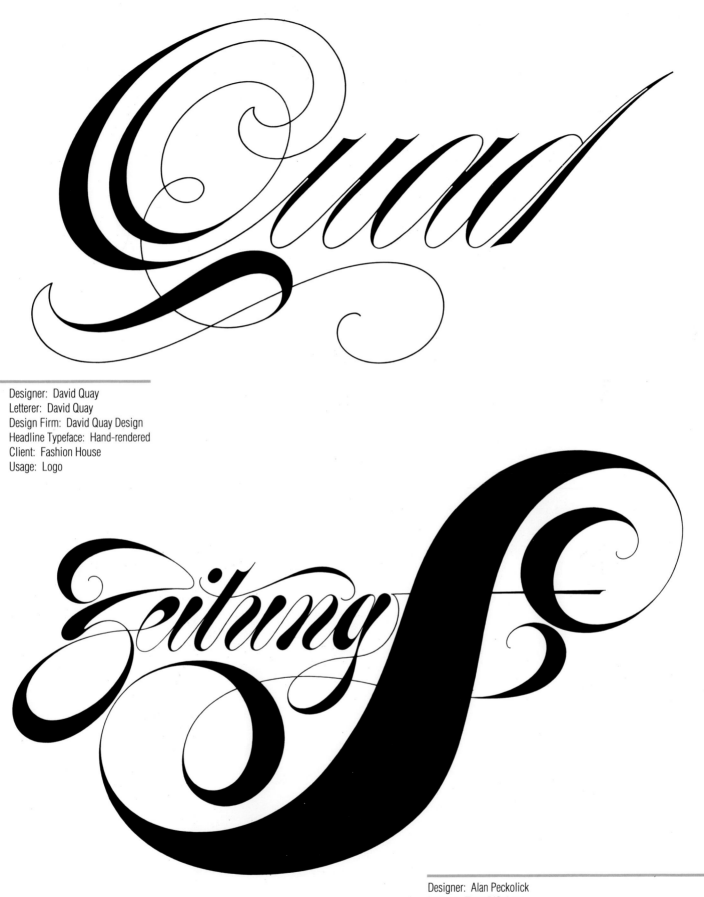

Designer: David Quay
Letterer: David Quay
Design Firm: David Quay Design
Headline Typeface: Hand-rendered
Client: Fashion House
Usage: Logo

Designer: Alan Peckolick
Letterer: Tony DiSpigna
Design Firm: Lubalin Peckolick
Headline Typeface: Hand-rendered
Client: Zeitung F
Usage: Newspaper masthead

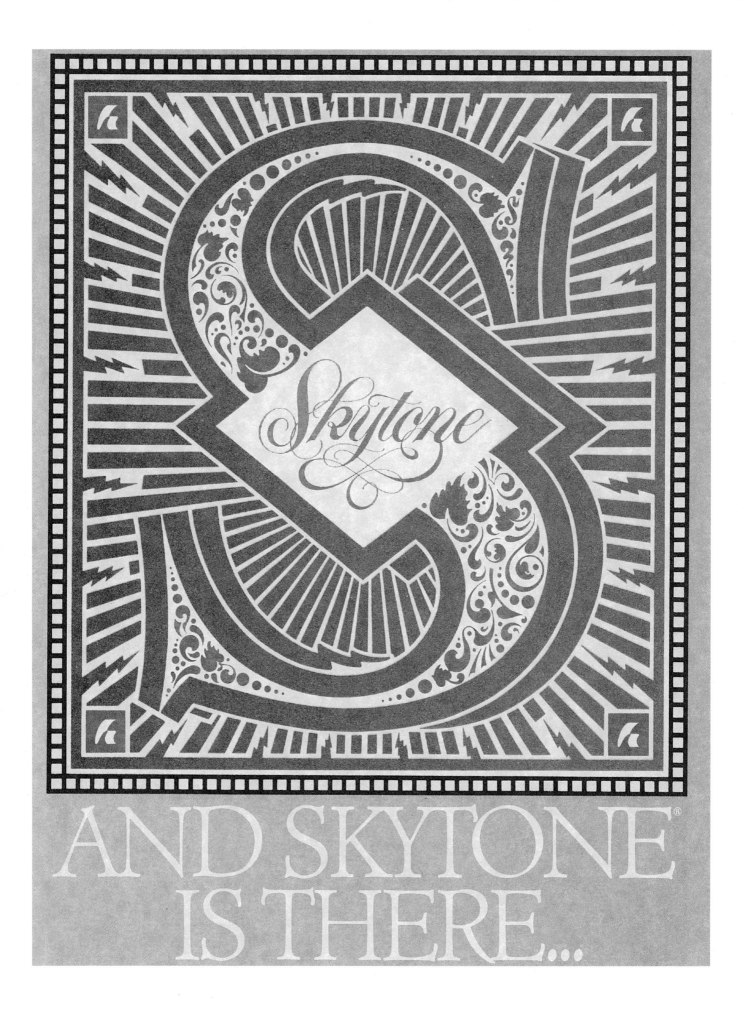

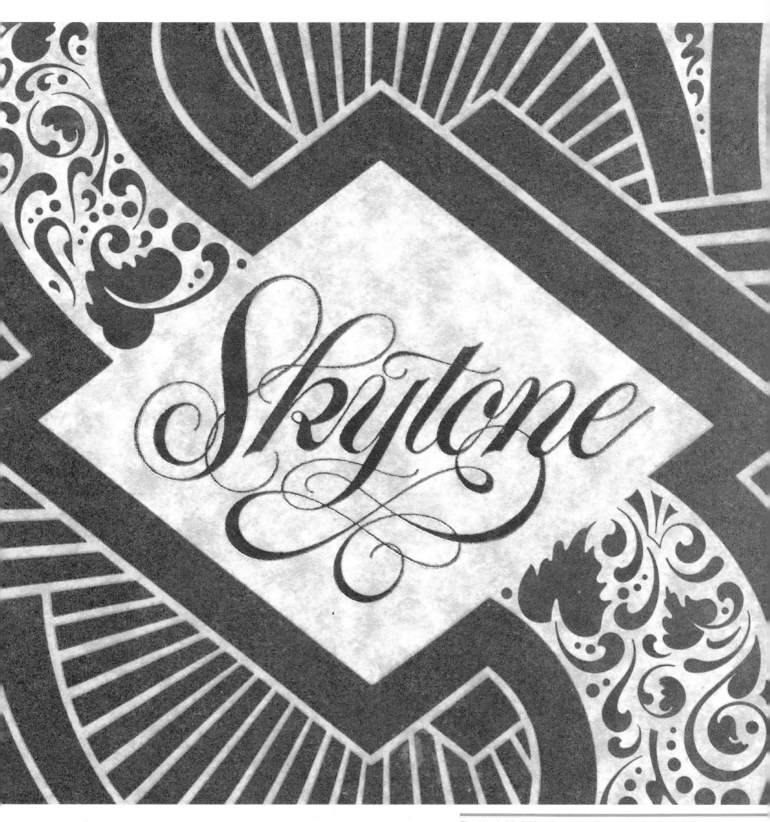

The idea behind this paper promotion was to demonstrate the dignity, grace and traditional beauty inherent in the parchment stock. The use of muted, tonal colors applied by foil stamping helps establish this feeling and complements the flourishes and script letterforms.

Designer: David Brier
Letterer: David Brier
Design Firm: DBD International, Ltd.
Headline Typeface: Administer Light & Hand Lettering
Client: Hopper Papers
Usage: Promotional brochure

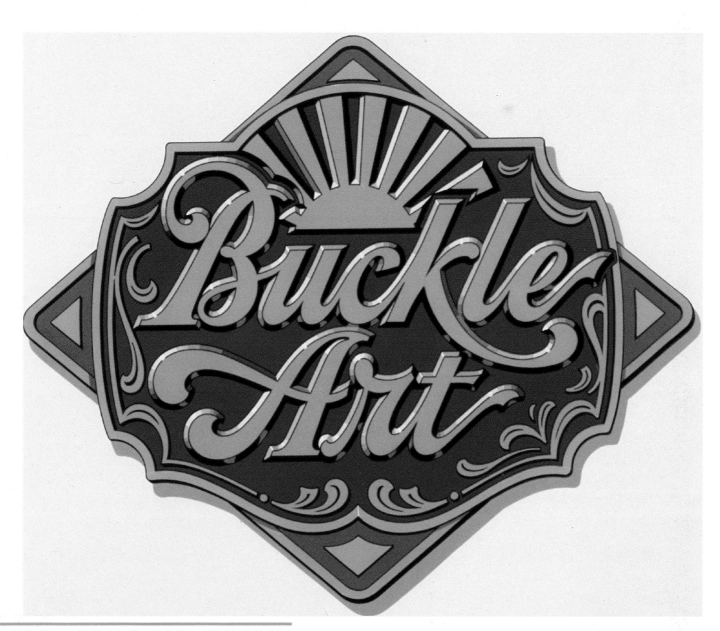

Art Director: Kit Hinrichs, Jonson, Pedersen, Hinrichs & Shakery
Designer/Letterer: Gerard Huerta
Design Firm: Gerard Huerta Design, Inc.
Headline Typeface: Hand-rendered
Client: Potlatch
Usage: Magazine article on belt buckles

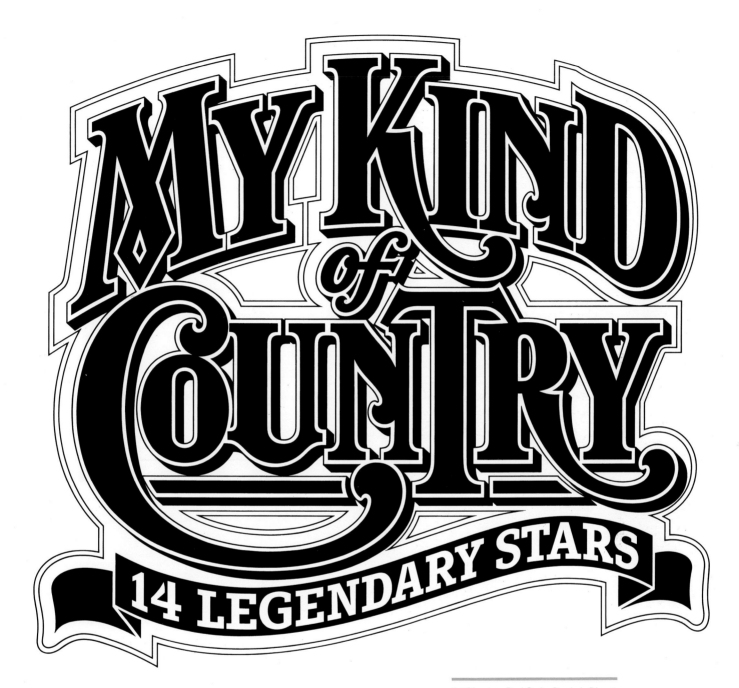

Art Director: Paul Omin, Reader's Digest
Designer/Letterer: Gerard Huerta
Design Firm: Gerard Huerta Design, Inc.
Headline Typeface: Hand-rendered
Client: Reader's Digest
Usage: Album cover

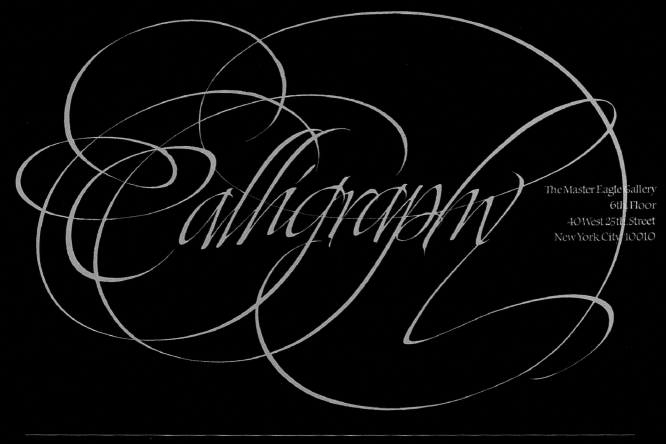

Designer: John Stevens
Letterer: John Stevens
Design Firm: John Stevens Design
Headline Typeface: Calligraphy
Text Typeface: Hand-rendered
Client: Society of Scribes
Usage: Poster commemorating S.O.S. 10th Anniversary

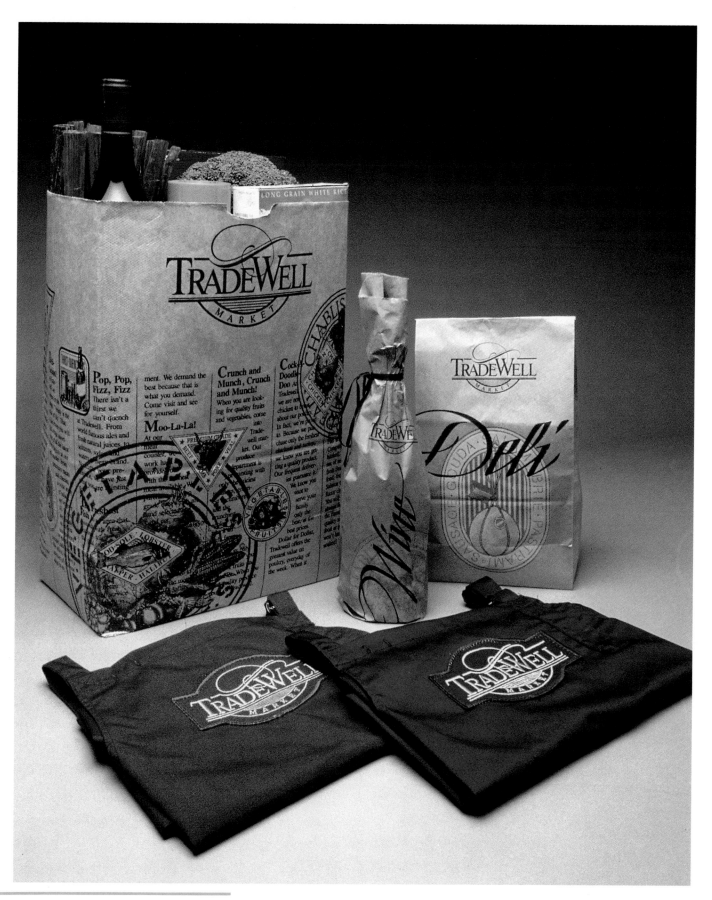

Designers: Jack Anderson, Luann Bice, Mary Hermes
Design Firm: Hornall Anderson Design Works
Headline Typeface: Customized Times Roman
Client: Tradewell
Usage: Corporate identity system for grocery store

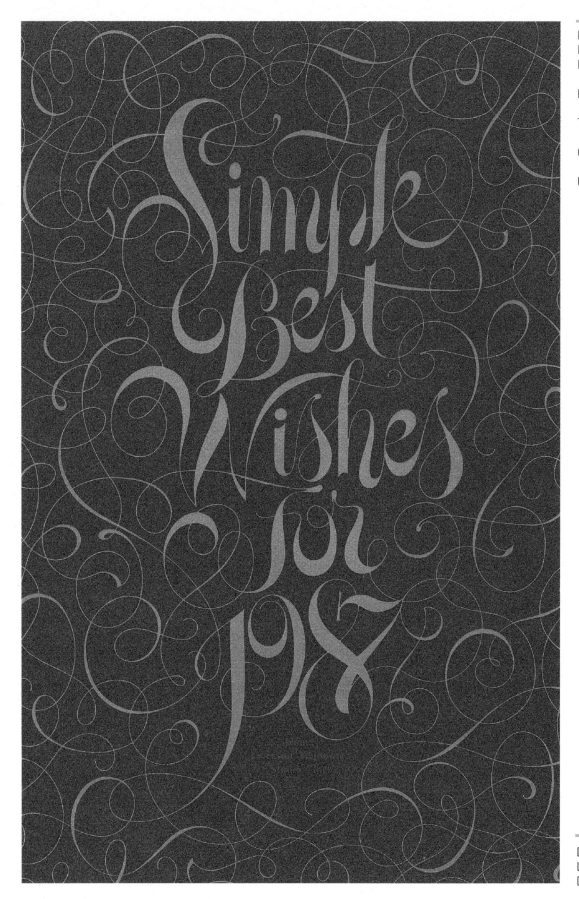

Designer: Jurek Wajdowicz
Letterer: Ted Szumilas
Design Firm: Emerson,
 Wajdowicz Studios, Inc.
Headline Typeface: Hand-
 rendered
Text Typeface: Franklin
 Gothic Condensed
Client: Emerson, Wajdowicz
 Studios, Inc.
Usage: Self promotion
 card/poster

Designer: John Stevens
Letterer: John Stevens
Design Firm: John Stevens
 Design
Headline Typeface: Hand-
 lettered
Text Typeface: Calligraphy
Client: Headliners Identicolor
Usage: Calendar/Poster

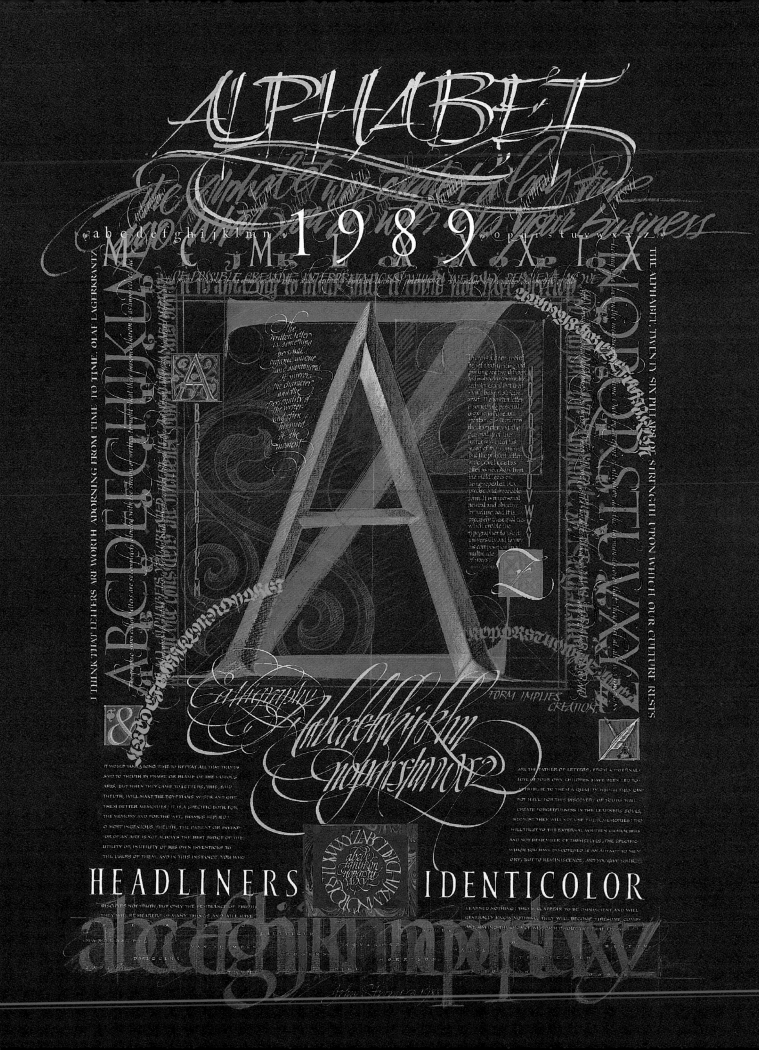

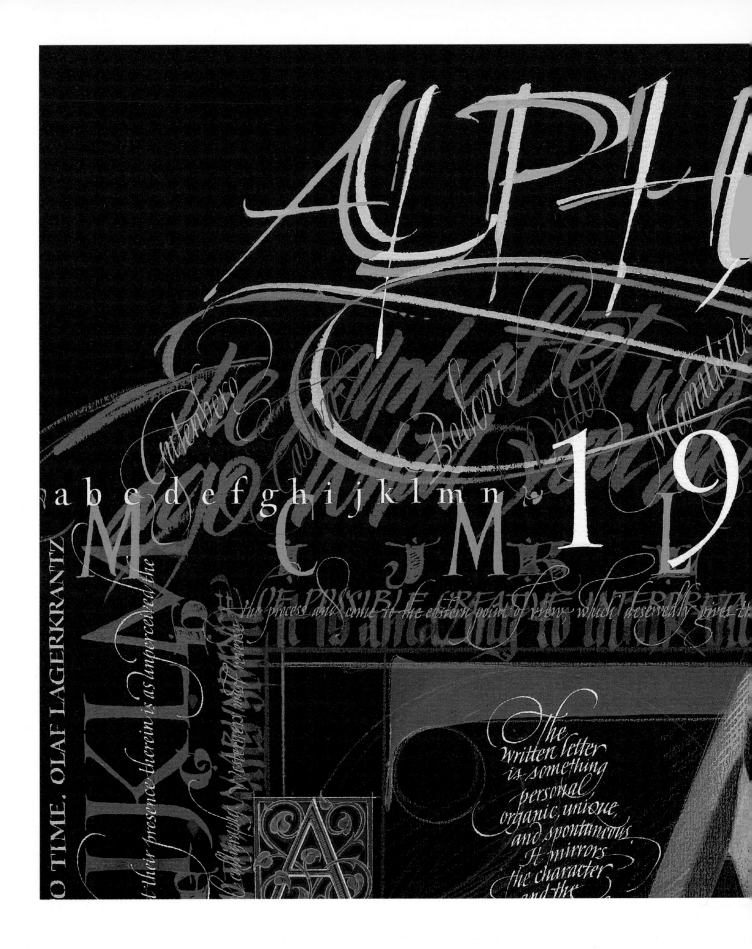

the written letter is something personal organic, unique, and spontaneous. It mirrors the character and the

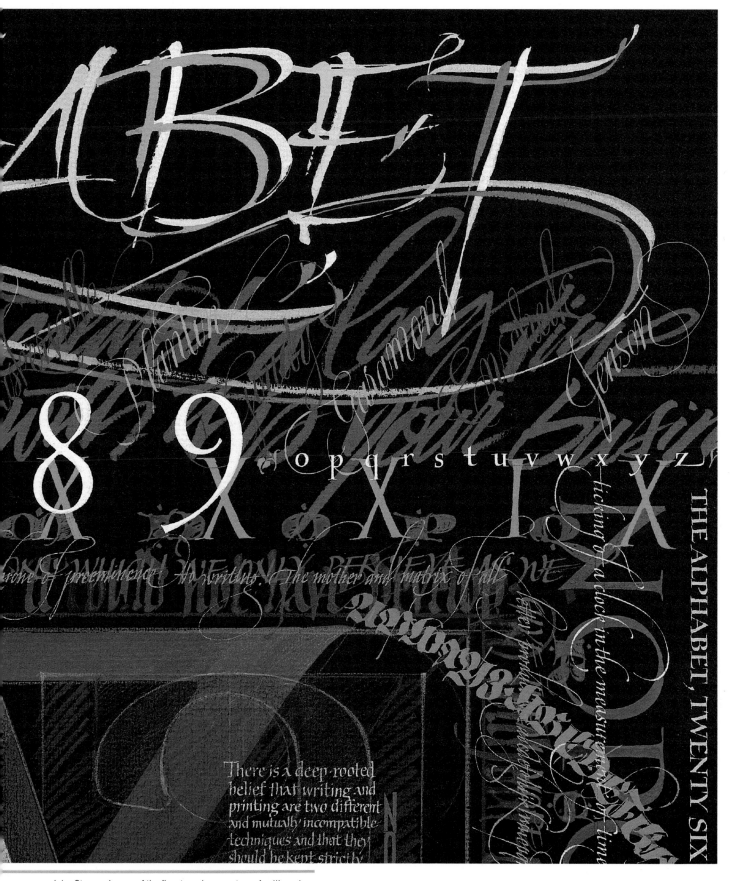

John Stevens is one of the finest modern masters of calligraphy in the world. He can create a complex, multi-level piece such as the one shown here and give its seemingly disparate elements an otherwise invisible harmony. At first, there is one striking visual image. Beyond that initial impression, each type treatment attracts the eye in turn. This is more like a movie than a print.

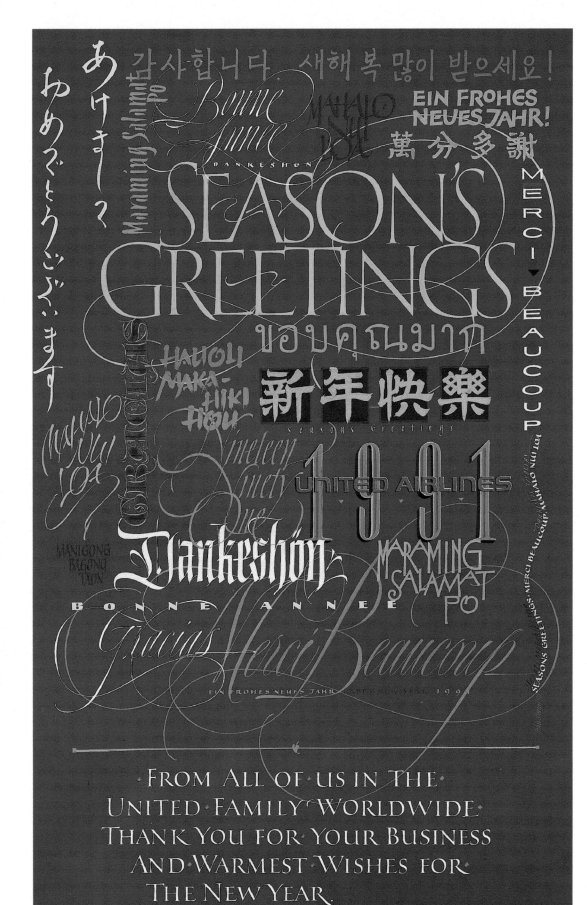

Art Director: Warrick Hutton, United Airlines
Designer/Letterer: John Stevens
Design Firm: John Stevens Design
Headline Typeface: Calligraphy
Text Typeface: Calligraphy and hand-lettering
Client: United Airlines
Usage: "Thank You" for members of Mileage Plus Club

Designer: Lance Anderson
Letterer: Lance Anderson
Design Firm: Lance Anderson Design
Headline Typeface: Based on Latin Bold
Text Typeface: Bank Gothic, Copperplate Gothic, hand-lettering and calligraphy
Client: Rainier Brewing and Chiat Day/Mojo Advertising, San Francisco
Usage: Packaging

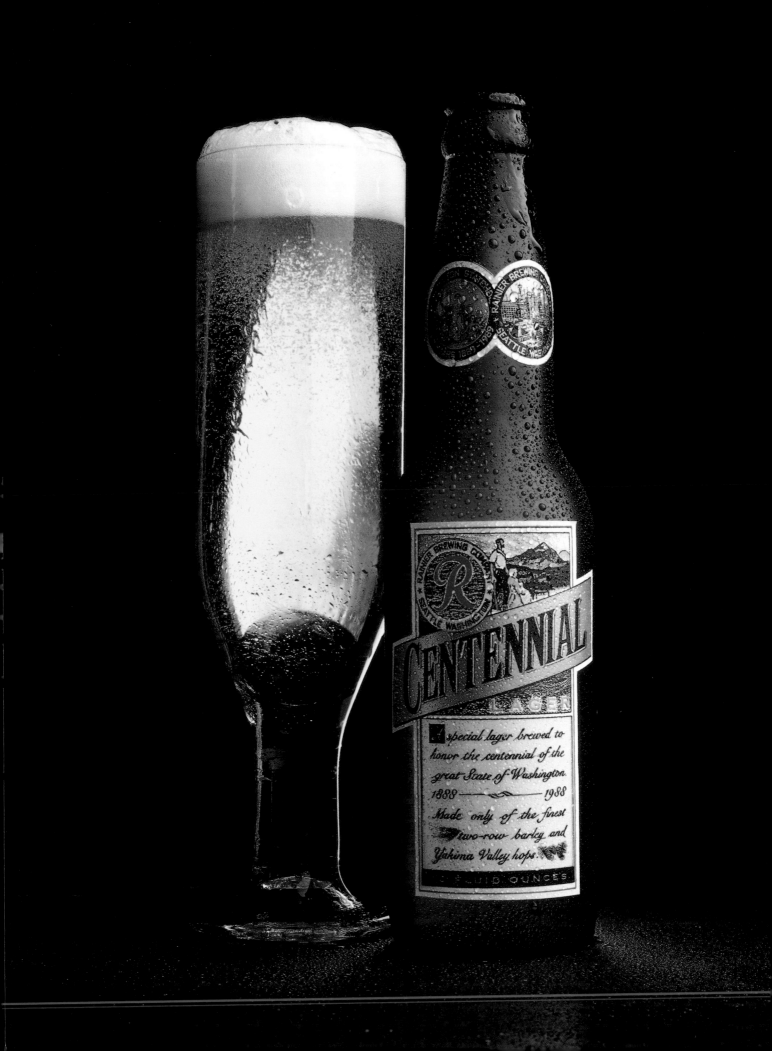

TYPE THAT BREAKS THE RULES

*O*ften type must challenge preconceptions in approach or introduce something unique in order to communicate. Solutions that incorporate this approach challenge notions of what type can—or should—be. Rules such as "Use only one typeface" or "All type should be horizontal" are often abandoned.

The works displayed here involve considerable manipulation of type—unusual letterforms or letter spacing, the creation of words within words, or the unusual positioning of type in vertical or abstract arrangements.

The common thread linking such a disparate group of works is an exploration of the patterns formed by words and letters. This is a hallmark of the work done for Phil's Photo by James Hellmuth and in the poster series done for PM Typography by Tim Girvin, Milton Glaser, Joseph Essex and Seymour Chwast.

In typography, as in any art form, limits must generally be observed. But at times, testing these boundaries leads to new, important growth of the art form.

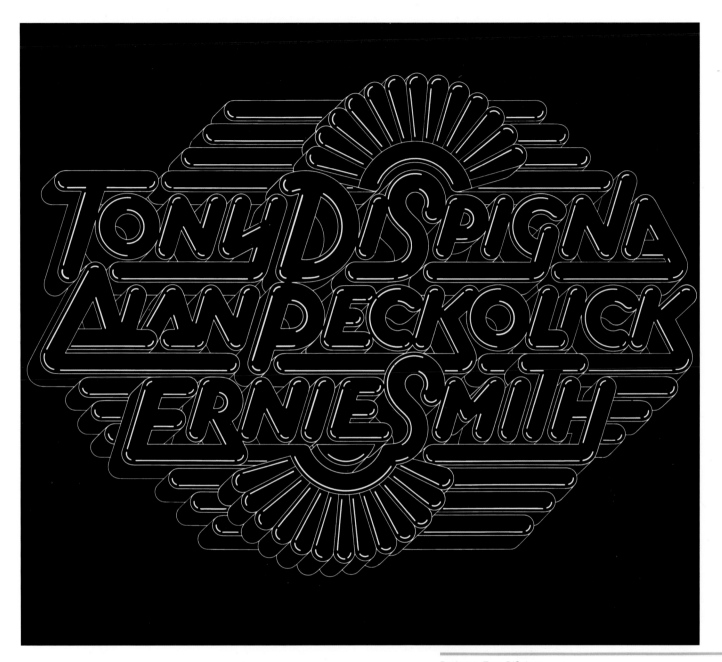

Designer: Tony DiSpigna
Letterer: Tony DiSpigna
Design Firm: Herb Lubalin Associates, Inc.
Headline Typeface: Hand-lettered
Client: *Graphis* magazine
Usage: Magazine cover

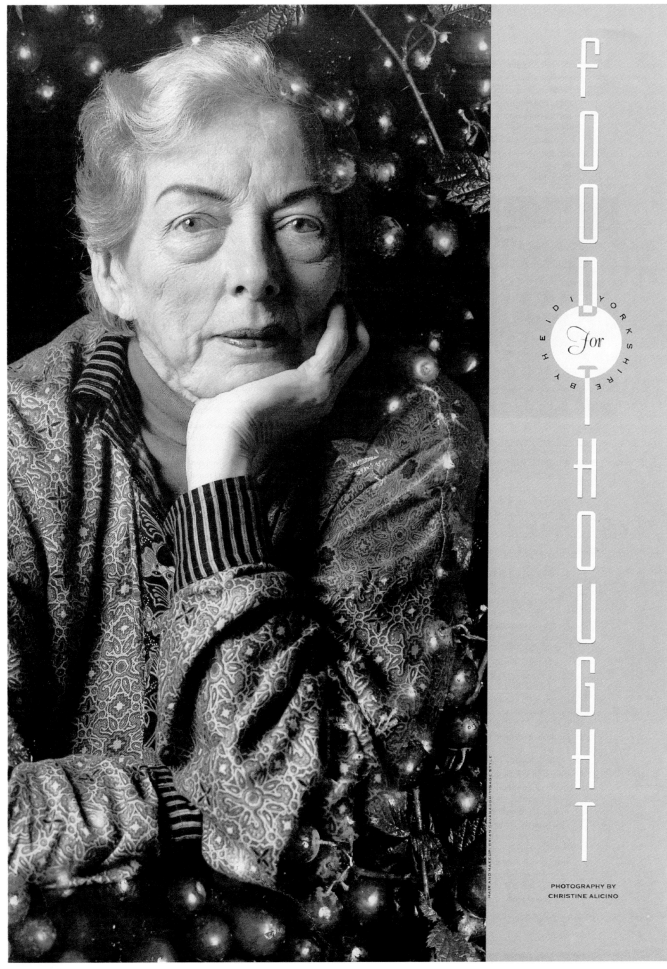

FOOD for THOUGHT

BY HEIDI YORKSHIRE

HAIR AND MAKEUP: BRIAN CAVANAUGH/VISAGE STYLE

PHOTOGRAPHY BY
CHRISTINE ALICINO

Designer: Michael Brock
Design Firm: Michael Brock
 Design
Headline Typeface: LA Style
 No. 1
Text Typeface: Magnum
 Gothic Medium
Client: *LA Style*
Usage: Opening page of
 magazine's food section

This simple treatment is very
effective. The headline dis-
plays a delicate flair and quiet
grace.

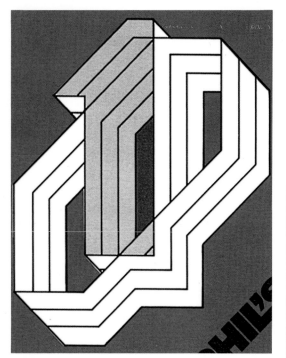

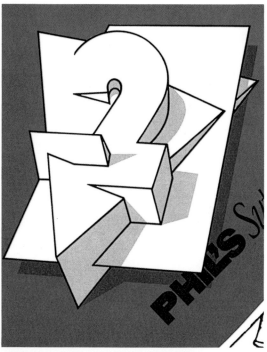

Designer: James Hellmuth
Letterer: James Hellmuth
Design Firm: James Hellmuth Design
Primary Typeface: Hand-rendered
Client: Phil's Photo
Usage: Book's section openers

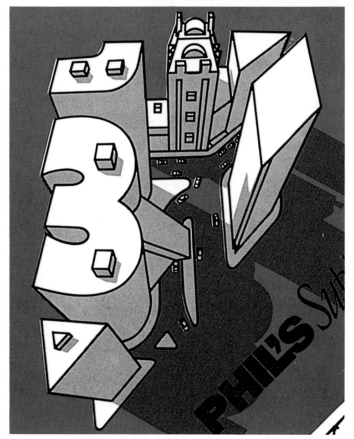

Designer: Louise Fili
Design Firm: Louise Fili, Ltd.
Headline Typeface: Eagle Bold
Client: Society of Publication
 Designers
Usage: Call-for-entries poster

SOCIETY OF

PUBLICATION

DESIGNERS

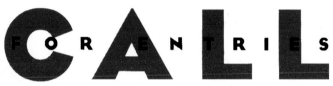

CALL FOR ENTRIES

YOU ARE INVITED TO PARTICIPATE IN THE S·P·D· 20TH ANNUAL COMPETITION CELEBRATING EXCELLENCE IN PUBLI‑ CATION DESIGN

ALL ENTRIES

MUST BE

RECEIVED

BY JAN.

30TH

1985

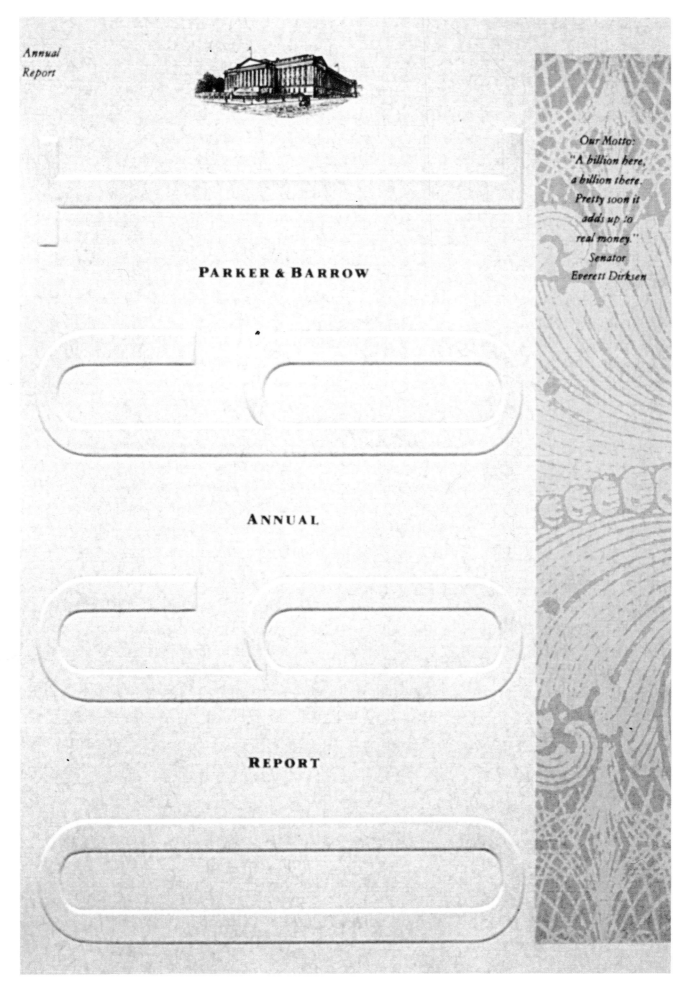

PARKER & BARROW

ANNUAL

REPORT

Our Motto:
"A billion here,
a billion there.
Pretty soon it
adds up to
real money."
Senator
Everett Dirksen

Designers: David Brier, Paul
 A. Minigiello
Design Firm: DBD
 International, Ltd.
Headline Typeface:
 Garamond Bold & Hand
 Lettering
Text Typeface: Garamond
 #49 Italic
Client: Karr Graphics
Usage: Page from brochure

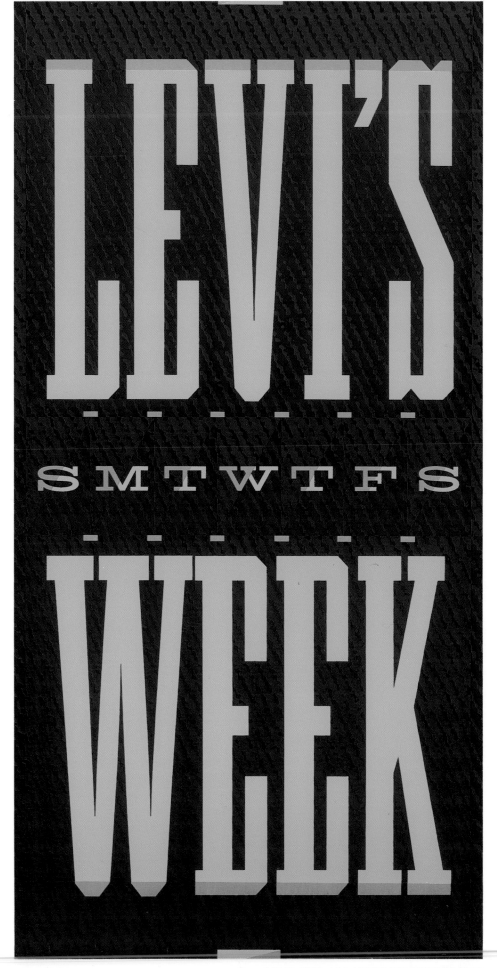

Designer: Neal Zimmermann
Design Firm: Zimmermann Crowe Design
Headline Typeface: Customized type based on
 Grecian XXX Condensed
Text Typeface: Customized type based on
 Grecian XXX Condensed
Client: Levi Strauss & Co.
Usage: Levi's Week retailers promotional
 poster

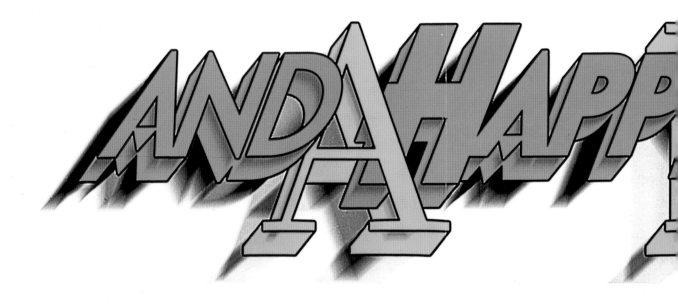

Designer: James Hellmuth
Design Firm: James Hellmuth Design
Headline Typeface: Various
Client: Phil's Photo
Usage: Mailer/New Year card

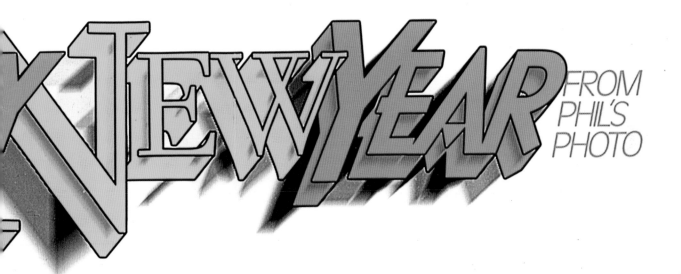

NEW YEAR FROM PHIL'S PHOTO

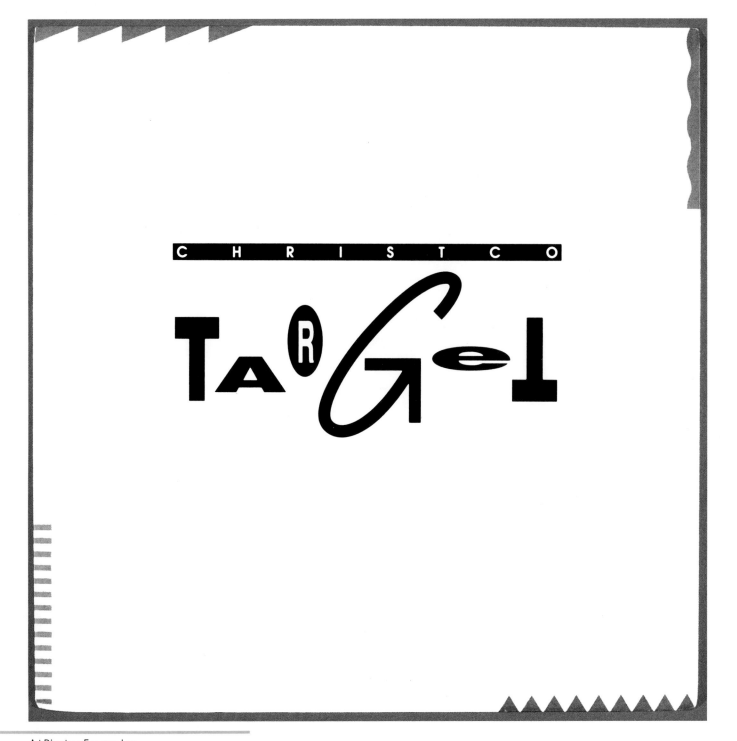

Art Director: Freeman Lau
Designer: Benny Au
Design Firm: Kan Tai-keung Design & Associates, Ltd.
Headline Typeface: Mixed
Text Typeface: Helvetica
Client: Christco Professional Photo Services
Usage: Promotion

Designer: Julian Waters
Letterer: Julian Waters
Design Firm: Julian Waters Letterforms
Headline Typeface: Hand-lettered
Text Typeface: Diotima Caps (address line)
Client: Julian Waters
Usage: Self-promotion/season's greetings poster

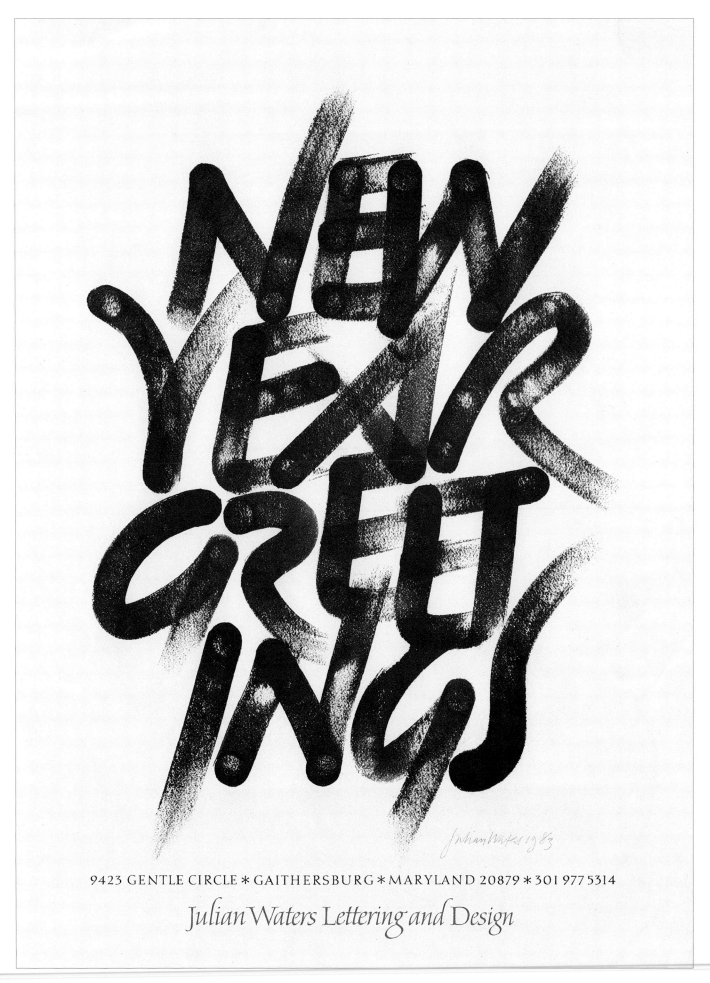

NEW YEAR GREETINGS

Julian Waters 1983

9423 GENTLE CIRCLE ∗ GAITHERSBURG ∗ MARYLAND 20879 ∗ 301 977 5314

Julian Waters Lettering and Design

Art Director: Harry Fremantle, Atlantic Records
Designer/Letterer: John Stevens
Design Firm: John Stevens Design
Headline Typeface: Hand-rendered
Client: Atlantic Records
Usage: Album cover/CD packaging

Designer: Tim Girvin
Letterer: Tim Girvin
Design Firm: Tim Girvin Design, Inc.
Headline Typeface: Dominic's/Girvin Custom
Client: PM Typography
Usage: Promotion

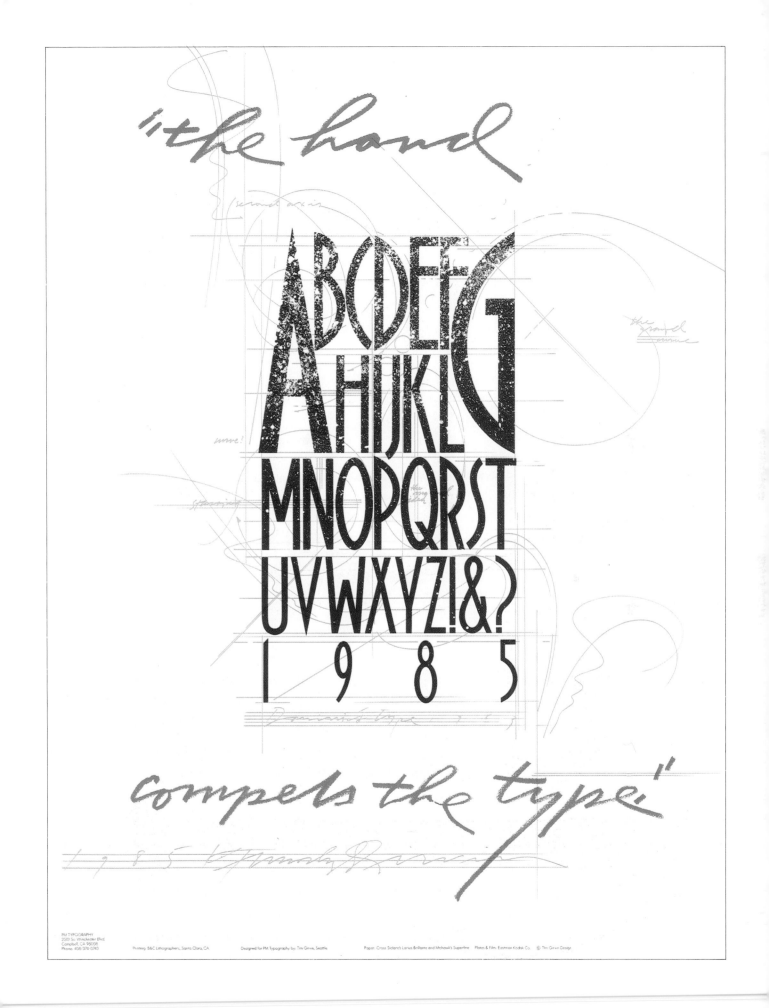

Designer: Milton Glaser
Letterer: Milton Glaser
Design Firm: MG, Inc.
Headline Typeface: Hand-
rendered Gothic Bold
Text Typeface: ITC
Cheltenham and ITC
Avant Garde
Client: PM Typography
Usage: Promotion

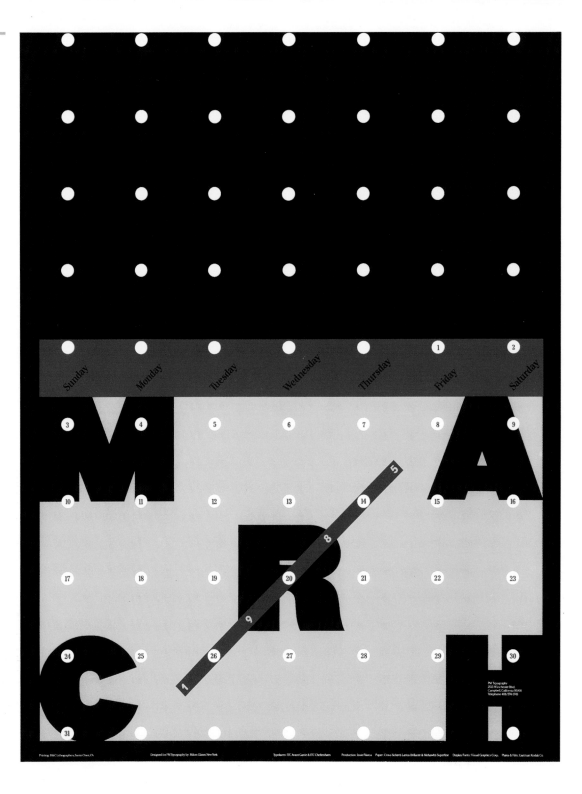

Designer: Joseph Michael
Essex
Design Firm: Essex Two, Inc.
Headline Typeface: Futura
Text Typeface: Futura
Client: PM Typography
Usage: Promotion calendar

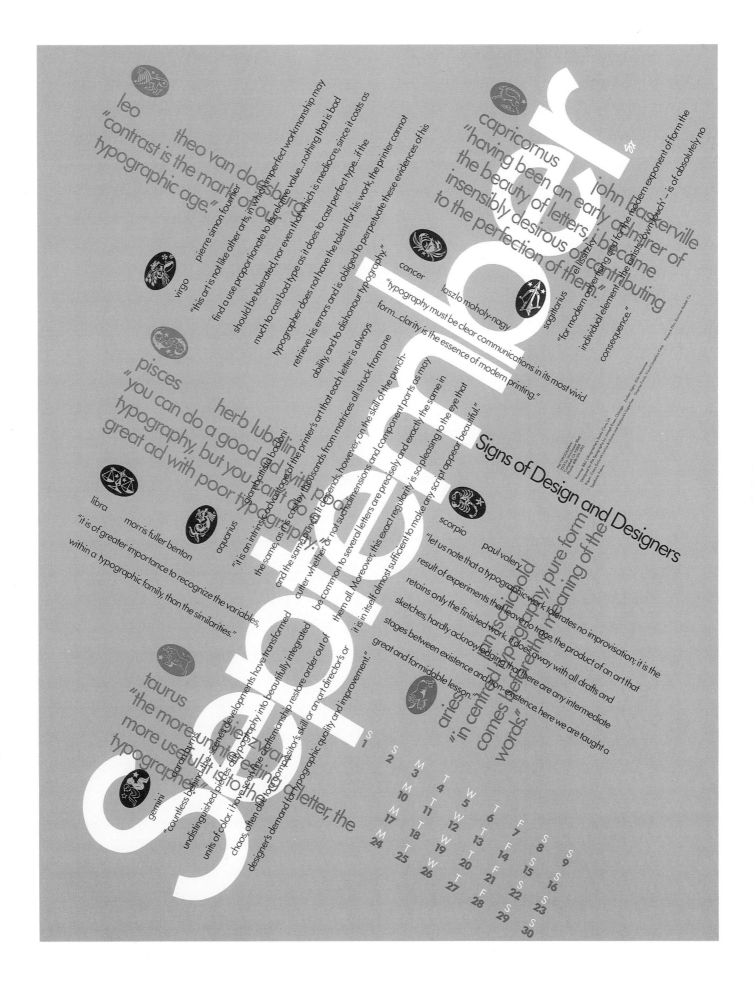

Signs of Design and Designers

capricornus
john baskerville
"having been an early admirer of the beauty of letters...i became insensibly desirous of contributing to the perfection of them."

el lissitzky
"...for modern advertising and for the modern exponent of form – the artists' showtouch' – is of absolutely no individual element...the consequence."

cancer
laszlo moholy-nagy
"typography must be clear communications in its most vivid form...clarity is the essence of modern printing."

leo
theo van doesburg
"contrast is the mark of our typographic age."

pierre simon fournier
"this art is not like other arts, in which imperfect workmanship may find a use proportionate to its relative value...nothing that is bad should be tolerated, nor even that which is mediocre; since it costs as much to cast bad type as it does to cast perfect type...if the typographer does not have the talent for his work, the printer cannot retrieve his errors and is obliged to perpetuate these evidences of his ability, and to dishonour typography."

virgo

pisces
herb lubalin
"you can do a good ad with poor typography, but you can't do a great ad with poor typography."

giambattista bodoni
"it is an intrinsic advantage of the printer's art that each letter is always the same, as it is cast by thousands from matrices all struck from one and the same punch...it depends, however, on the skill of the punch-cutter whether or not such dimensions and component parts as may be common to several letters are precisely and exactly the same in them all. Moreover, this exact regularity is so pleasing to the eye that it is in itself almost sufficient to make any script appear beautiful."

libra
morris fuller benton
"it is of greater importance to recognize the variables, within a typographic family, than the similarities."

aquarius

scorpio
paul valéry
"let us note that a typographic work tolerates no improvisation; it is the result of experiments that leave no trace; the product of an art that retains only the finished work. it does away with all drafts and sketches, hardly acknowledging that there are any intermediate stages between existence and non-existence. here we are taught a great and formidable lesson."

aries
"in central typography, pure form comes more and more to the fore... here the very meaning of the words."

taurus
"the more uniform a design becomes, the more useful it is to the typographer."

sara burman
"...countless undistinguished pieces of typography restore order out of chaos, often through the compositor's skill or an art director's or designer's demand for typographic quality and improvement."

gemini

aquarius

PAS TYPOGRAPHY
2355 Mission Street
Santa Cruz, CA 95060
Phone (408) 426-5858

Imagesetting by BRL Typesetting, Santa Cruz, CA
Printing by PAS Typography by Archive Press, Chicago
Poster: Great Type and Lettering Designs
Typeface: Futura

Zodiac Signs: Adobe Systems
Display Fonts: Visual Graphics Corp

Printed 4,000, Eastman Kodak Co.

S						
	S					
1	2	M				
	3	T				
	4	W	5	T		
10	11	12	13	F		
17	18	19	20	21	22	23
24	25	26	27	28	29	30

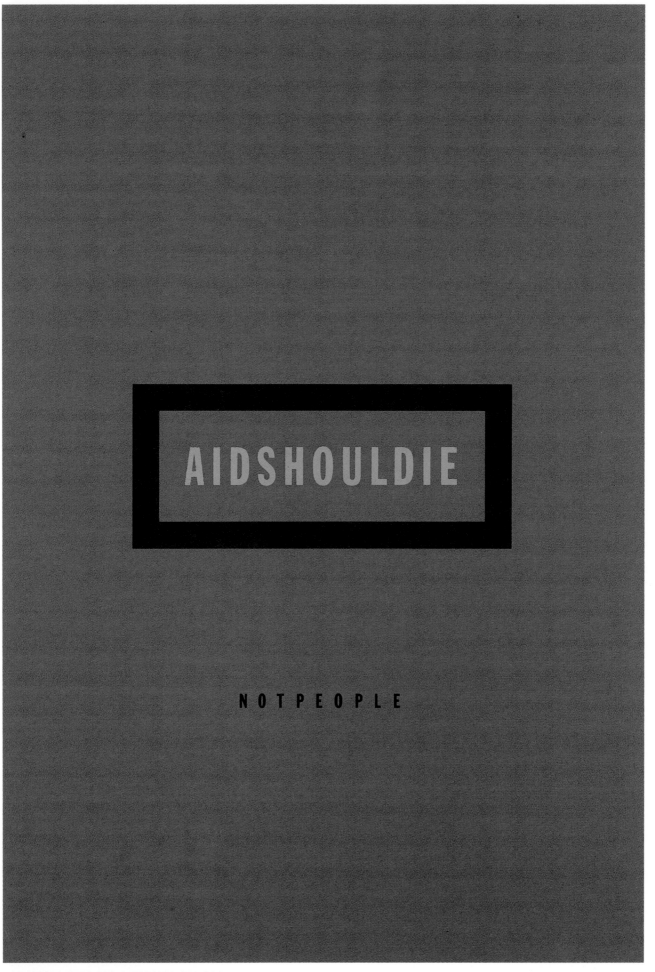

AIDSHOULDIE

NOTPEOPLE

Designer: Rick Valicenti
Design Firm: Thirst
Headline Typeface: Franklin
 Gothic
Client: Thirst
Usage: AIDS benefit

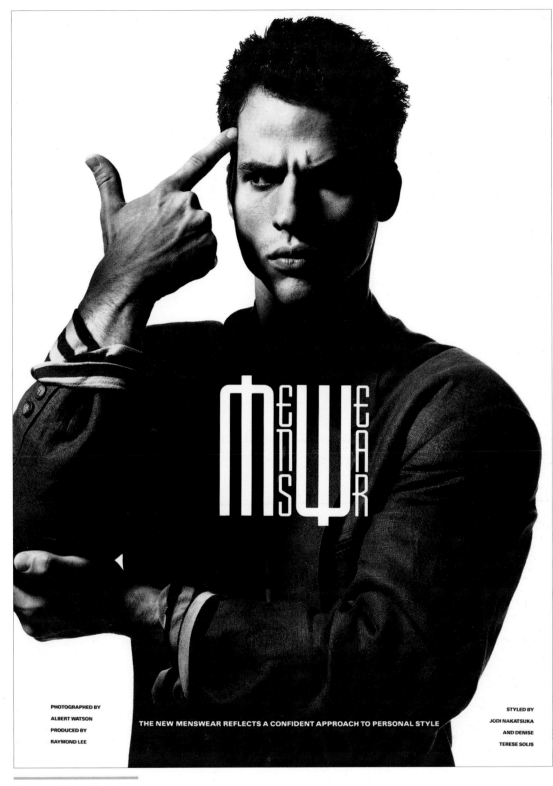

PHOTOGRAPHED BY
ALBERT WATSON
PRODUCED BY
RAYMOND LEE

THE NEW MENSWEAR REFLECTS A CONFIDENT APPROACH TO PERSONAL STYLE

STYLED BY
JODI NAKATSUKA
AND DENISE
TERESE SOLIS

Designer: Michael Brock
Design Firm: Michael Brock
 Design
Headline Typeface: LA Style
 No. 2
Text Typeface: Univers Extra
 Bold
Client: *LA Style*
Usage: Magazine fashion
 spread

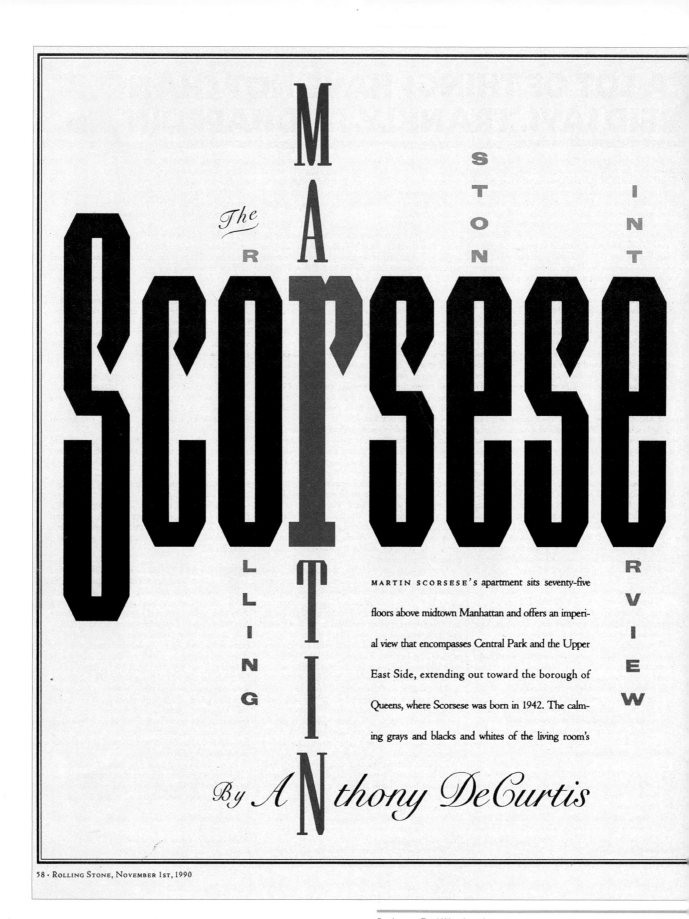

The Rolling Stone Interview

MARTIN Scorsese

MARTIN SCORSESE'S apartment sits seventy-five floors above midtown Manhattan and offers an imperial view that encompasses Central Park and the Upper East Side, extending out toward the borough of Queens, where Scorsese was born in 1942. The calming grays and blacks and whites of the living room's

By ANthony DeCurtis

Designer: Fred Woodward
Design Firm: Rolling Stone
Headline Typeface: Grecian
Text Typeface: Cloister
Client: *Rolling Stone*
Usage: Opening spread of magazine article

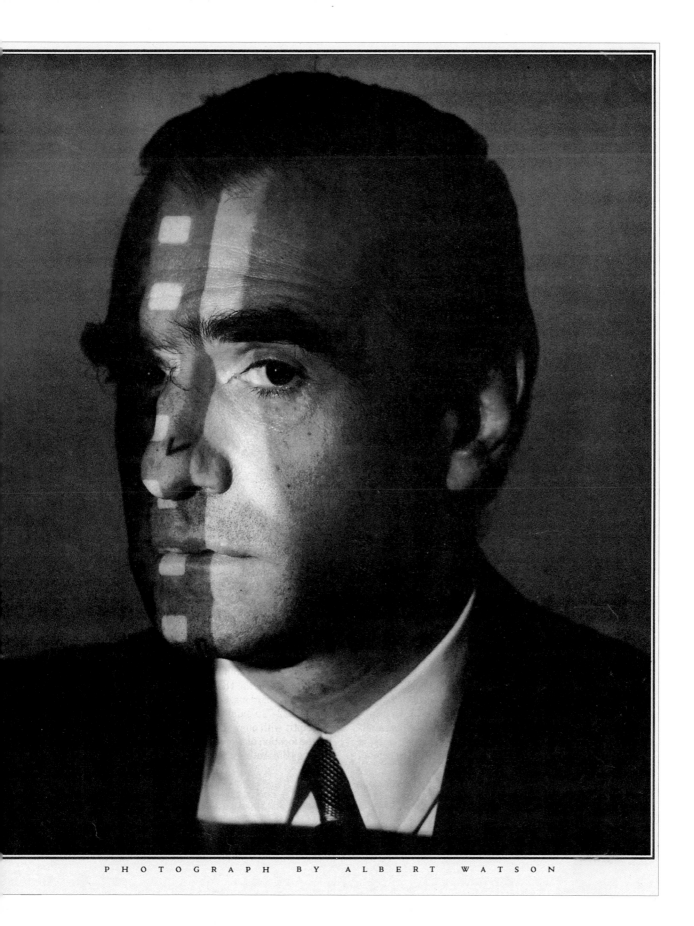

PHOTOGRAPH BY ALBERT WATSON

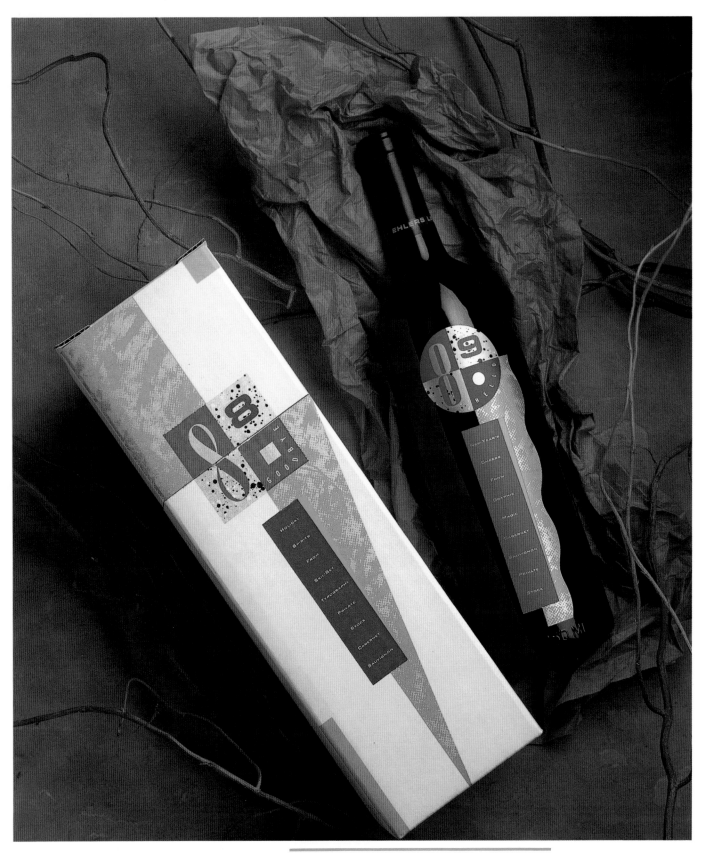

Designer: Steve Curry
Design Firm: Curry Design
Headline Typeface: Onyx, Helvetica Medium Extended, Bank
 Gothic Medium
Text Typeface: Bank Gothic Medium
Client: Skil-Set/Alpha Graphix Type House
Usage: Promotion for Skil-Set/Alpha Graphix Type House

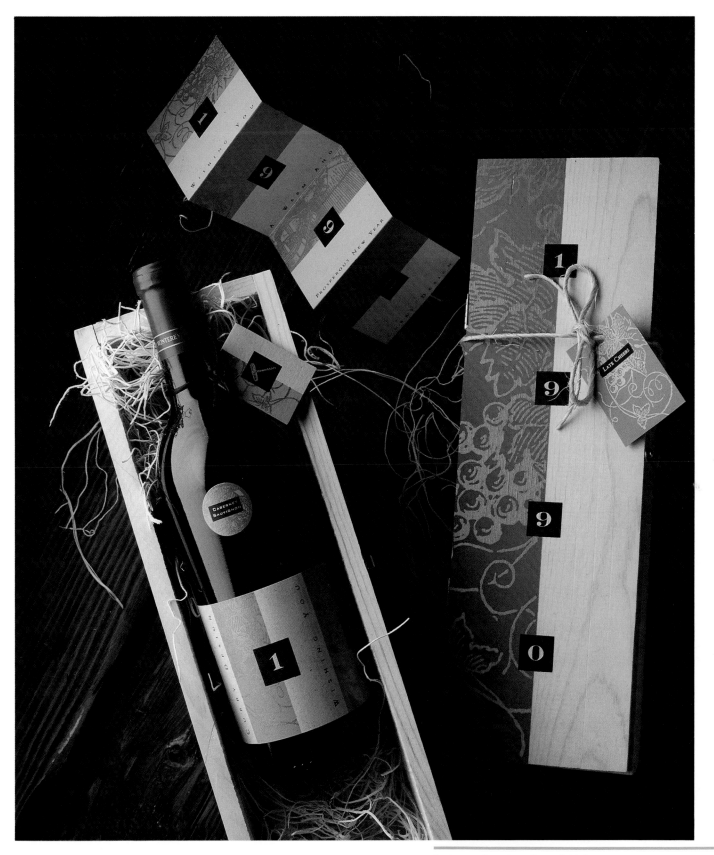

Designers: Steve Curry/Jason Schiedeman
Design Firm: Curry Design
Headline Typeface: Craw (numbers)
Text Typeface: Bembo
Client: Skil-Set/Alpha Graphix Type House
Usage: Promotion for Skil-Set/Alpha Graphix Type House

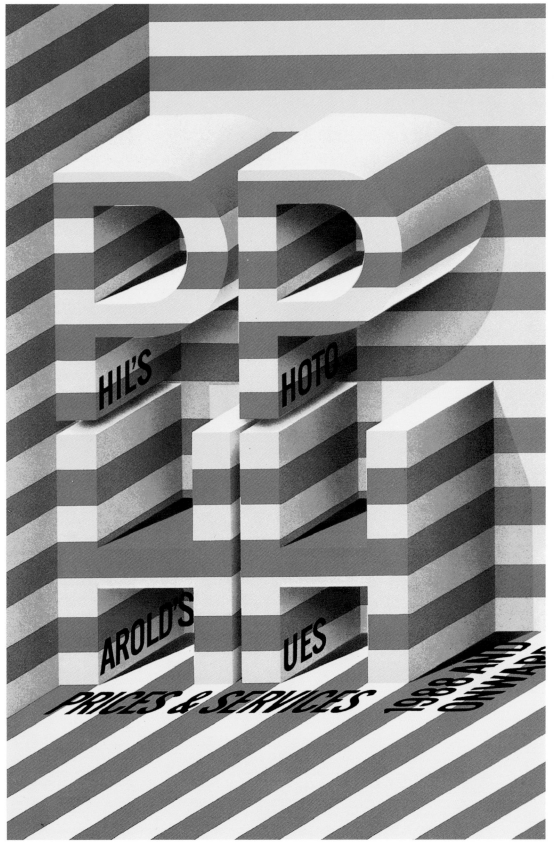

Designer: Seymour Chwast
Design Firm: The Pushpin
 Group
Headline Typeface: Various
Text Typeface: Futura
Client: PM Typography
Usage: Calendar

Designer: James Hellmuth
Design Firm: James Hellmuth Design
Headline Typeface: Altered Gothic
Client: Phil's Photo
Usage: Price list cover

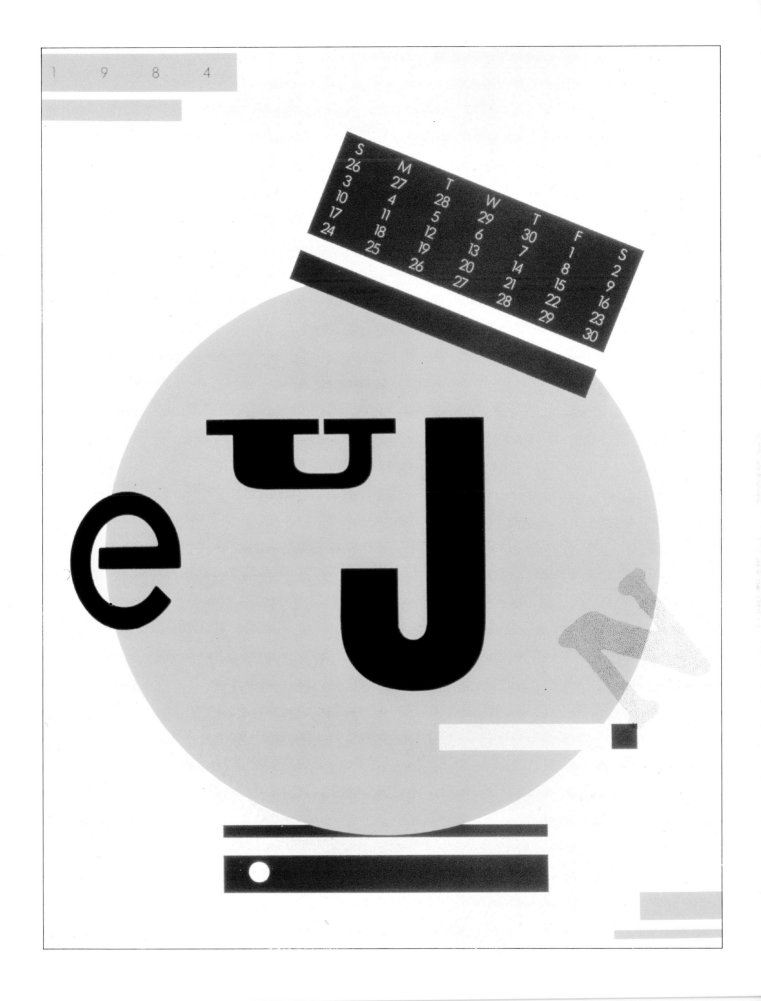

Flying Colors

Color Proofing Price List

Number of Colors	1	2	3	4	5	6
Up to 6 x 9	41.30	61.00	81.40	101.65	127.15	165.30
Additional Print	18.80	27.75	37.00	46.25	57.80	75.15
Up to 10 x 12	54.05	80.10	106.80	133.80	165.30	208.50
Additional Print	24.55	36.40	48.55	60.70	75.15	94.75
Up to 12 x 18	65.85	99.15	132.20	165.30	203.40	252.95
Additional Print	30.35	45.05	60.10	75.15	92.45	115.00
Up to 20 x 24	92.20	137.30	183.05	218.15	270.00	341.95
Additional Print	41.90	62.40	83.20	104.00	127.15	155.45

Prices subject to change without prior notice. ©Copyright 1987

No charge for matching primary PMS colors.
There will be a charge of $10.70 per color for mixing and matching
special colors.

Separation and negative opaquing will be charged at the prevailing
hourly rate or product charge.

Estimates available for volume work.

Above Schedule is for 18 to 24 Hour Service.
Custom Rub Off Transfers available from your art or from our vast
library of type faces in our photo library.

For special services:
6 hour service add 100% to above.
7 to 12 hour service add 75% to above.
13 to 17 hour service add 50% to above.

CARNASE
INC.
Computer ● Typography
(212) 674-1185

Designer: Tom Carnase
Letterer: Tom Carnase
Design Firm: Carnase, Inc.
Headline Typeface: Hand-rendered
Text Typeface: Garamond Ultra & Book Italic
Client: Carnase Computer Typography
Usage: Promotion

FLYING COLORS ©

Color Proofing Price List

Number of Colors	1	2	3	4	5	6
Up to 6 x 9	32.50	48.00	64.00	80.00	100.00	130.00
Additional Print	16.25	24.00	32.00	40.00	50.00	65.00
Up to 10 x 12	42.50	63.00	84.00	105.00	130.00	164.00
Additional Print	21.25	31.50	42.00	52.50	65.00	82.00
Up to 12 x 18	52.50	78.00	104.00	130.00	160.00	199.00
Additional Print	26.25	39.00	52.00	65.00	80.00	149.50
Up to 20 x 24	72.50	108.00	144.00	180.00	220.00	269.00
Additional Print	36.25	54.00	72.00	90.00	110.00	134.50

·Prices subject to change without prior notice.

No charge for matching primary PMS colors.
There will be a charge of $1.00 per color for mixing and matching special colors.

Separation and negative opaquing will be charged at the prevailing hourly rate, or product charge.

Estimates Available for volume work.

Above Schedule is for 18 to 24 Hour Service.

Custom Rub Off Transfers available from your art or from our vast library of type faces in our photo library.

For special services:
6 hour service add 100% to above.
7 to 12 hour service add 75% to above.
13 to 18 hour service add 50% to above.

CARNASE
Computer Typography
(212) 679-9880

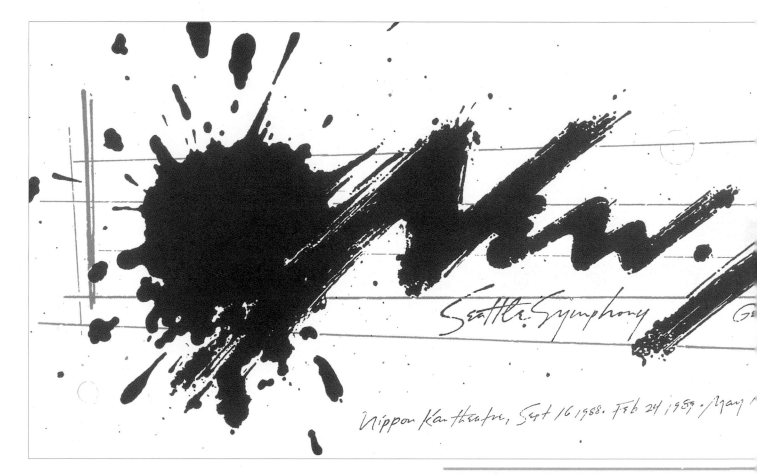

Art Director: Mary Macenka, Seattle Symphony
Designer/Letterer: Bruce Hale
Design Firm: Bruce Hale Design Studio
Headline Typeface: Hand-rendered
Client: Seattle Symphony
Usage: Promotion

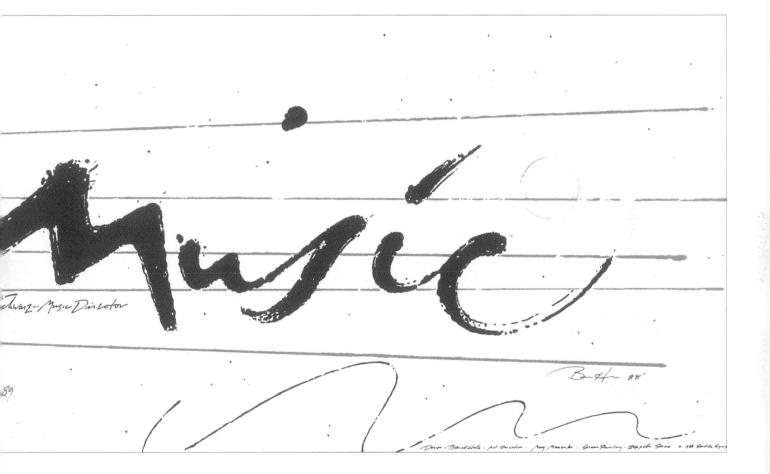

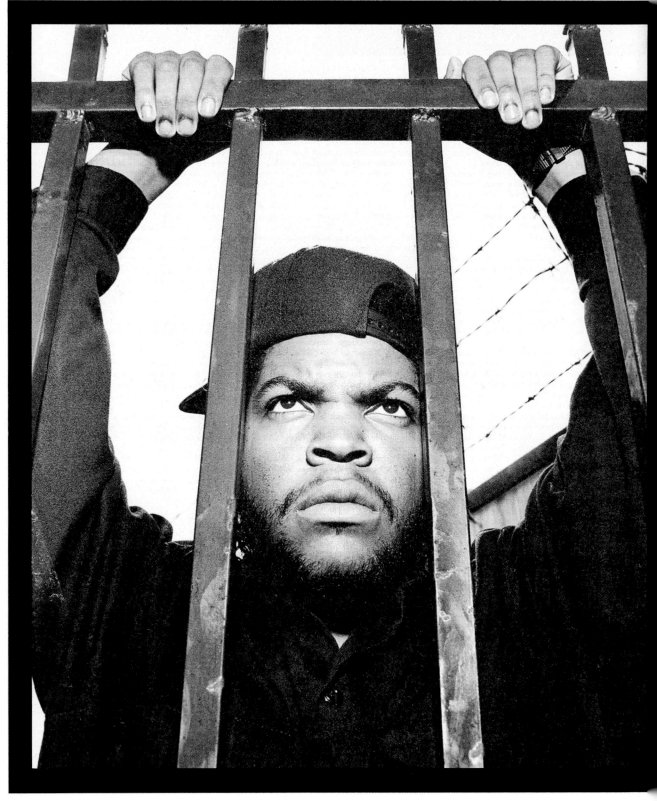

PHOTOGRAPHS BY BRIAN SMALE

Designer: Gail Anderson
Letterer: Dennis Ortiz-Lopez
Design Firm: Rolling Stone
Headline Typeface: Poster Gothic; Subhead: Marla
Text Typeface: Cloister
Client: *Rolling Stone*
Usage: Opening spread of magazine article

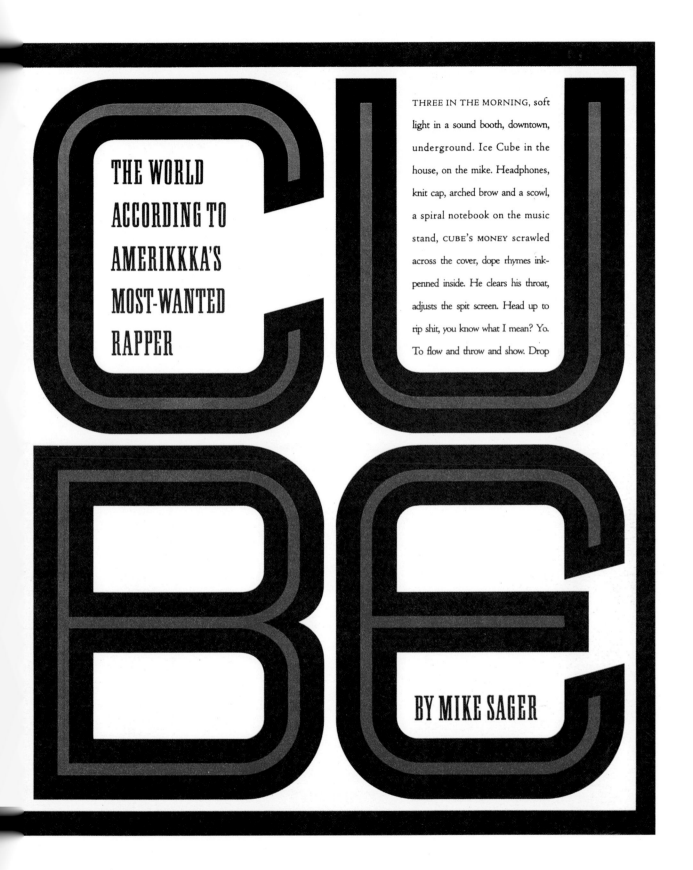

CUBE

THE WORLD ACCORDING TO AMERIKKKA'S MOST-WANTED RAPPER

THREE IN THE MORNING, soft light in a sound booth, downtown, underground. Ice Cube in the house, on the mike. Headphones, knit cap, arched brow and a scowl, a spiral notebook on the music stand, CUBE'S MONEY scrawled across the cover, dope rhymes ink-penned inside. He clears his throat, adjusts the spit screen. Head up to rip shit, you know what I mean? Yo. To flow and throw and show. Drop

BY MIKE SAGER

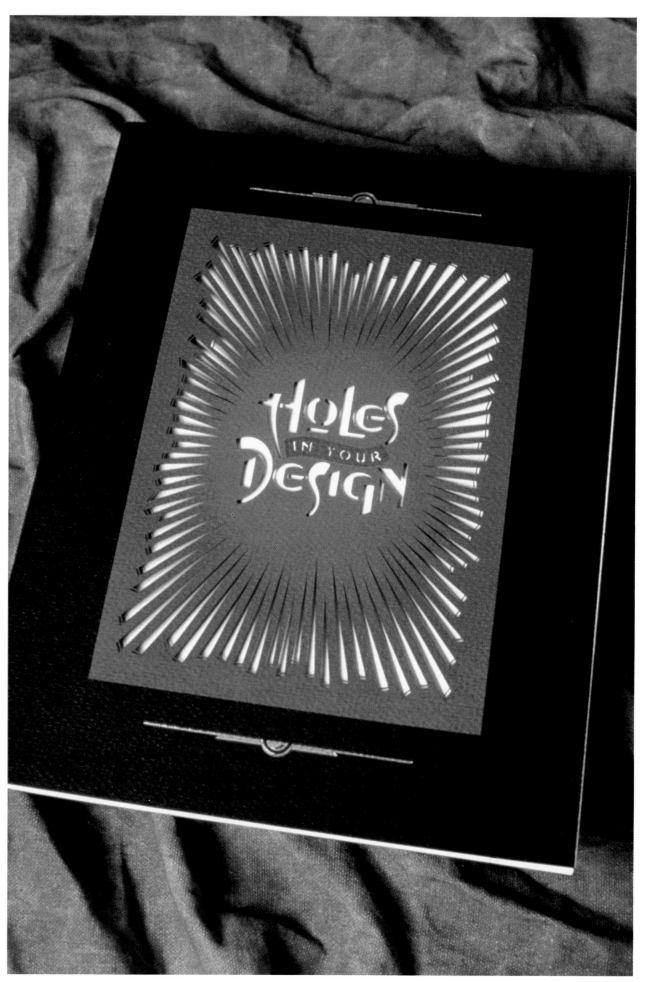

Designer: David Brier
Letterer: David Brier
Design Firm: DBD International, Ltd.
Headline Typeface: Hand-drawn
Client: Lasercraft
Usage: Promotional brochure cover

Art Director: Abie Sussman, David Mann Advertising
Designer/Letterer: Gerard Huerta
Design Firm: Gerard Huerta Design, Inc.
Primary Typeface: Hand-lettered
Client: Polydor Records
Usage: Album cover

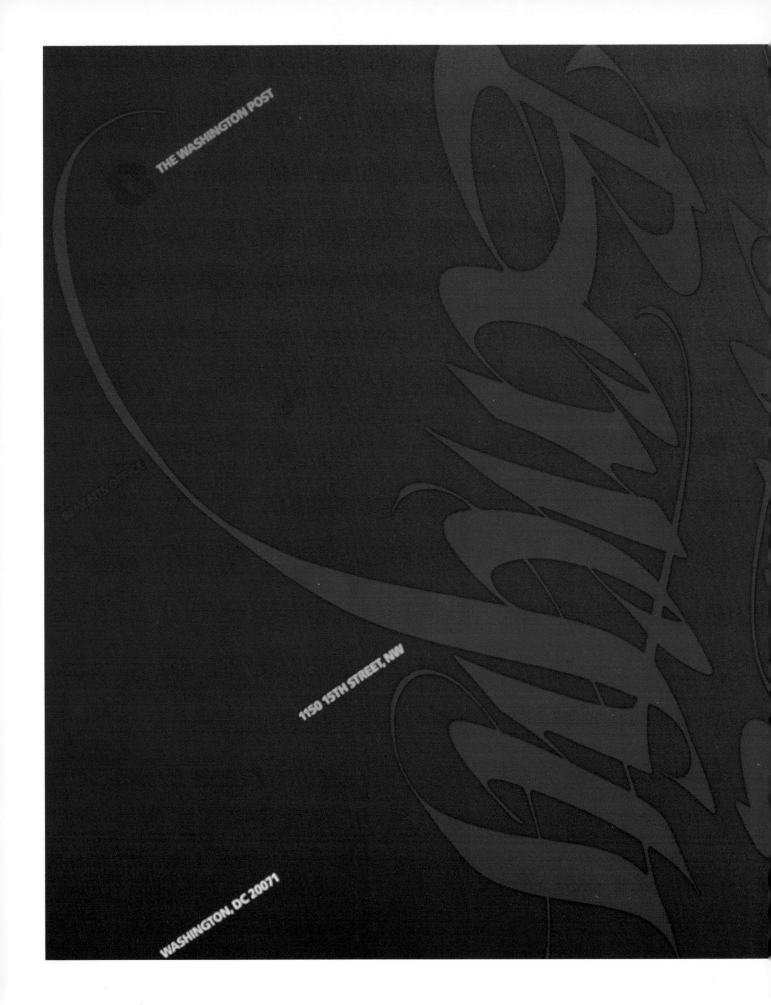

THE WASHINGTON POST

1150 15TH STREET, NW

WASHINGTON, DC 20071

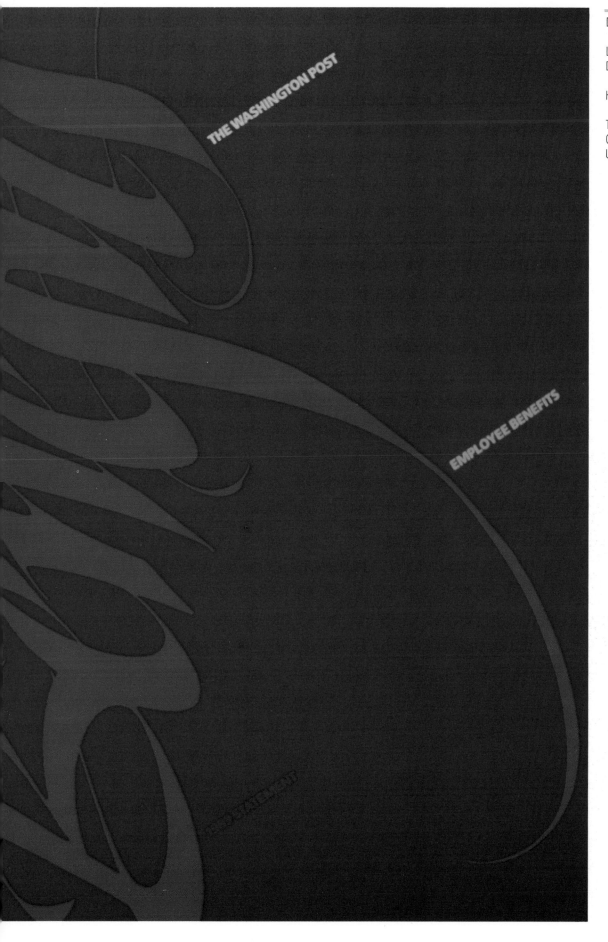

THE WASHINGTON POST

EMPLOYEE BENEFITS

Designers: Julian Waters,
 Jessica Wilson
Letterer: Julian Waters
Design Firm: Julian Waters
 Letterforms
Headline Typeface: Hand-
 lettered
Text Typeface: Helvetica
Client: *Washington Post*
Usage: Employee benefits
 cover

50

Mickey, o rato que trabalha somente nas revistas e como porteiro do parque de diversões mais famoso do mundo: Disneylandia. Hoje com nostalgia voltamos as velhas películas de desenhos animados com Mickey e Cia.

Essas obras de arte pouco mostradas já fazem parte da história do cinema. Mickey é agora a marca registrada a figura simbólica do império Disney.

Quando em 1928 Walt Disney pediu mais dinheiro para o distribuidor de sua série "Oswald" recebeu como resposta uma baixa nos seus honorários e a ameaça de continuarem sem ele.

Então com alguns dos seus mais fiéis colaboradores Disney criou em seu pequeno estúdio, numa só noite uma nova série de desenhos animados e com uma nova figura.

Era um rato, parecido com aqueles que se apreciava de

Walt Disney Productio...

Mickey

desenhos animados de Mickey.

vez em quando como figuras secundárias nas películas de "Alice no País das Maravilhas", em 1925. O desenhista principal, Ub Iwerks, realizou os primeiros filmes de Mickey quase que sozinho. A primeira película de desenhos animados com o rato Mickey foi intitulada: "Plane Crazy" (um jogo de palavras que podem significar tanto como totalmente louco ou louco avião), "The Gallopin Gaucho" já estava terminada mas Disney não tinha ainda uma distribuidora quando apareceu o primeiro filme sonoro "Jazz Singer" de All Jolson. Walt Disney entusiasmou-se e o terceiro filme de Mickey foi sonoro. "Steamboat Willie" teve sua estréia em 18 de novembro de 1928 no Colony Theatre em Nova York. Ao contrário dos filmes de Oswald", Disney assegurou todos os direitos sobre o rato. O resto é história.

Mouse.

Designer: Oswaldo Miranda
Design Firm: Miran Studio
Headline Typeface: Windsor Bold
Text Typeface: Times New Roman Italic
Client: *Raposa* Newspaper
Usage: Newspaper layout

Designer: Alan Peckolick
Letterer: Tony DiSpigna
Design Firm: Lubalin
 Peckolick
Headline Typeface: Hand-
 lettered
Client: *Idea* magazine
Usage: Cover design

CREDITS

P. 3 — © 1991 PM Typography. Used by permission.

Pp. 4 - 5 — © Cipriani Kremer Design Group. Used by permission.

P. 6 — © Lubalin Peckolick. Used by permission.

P. 7 — © Pentagram. Used by permission.

P. 8 — © Old Tyme. Used by permission.

P. 9 — © DBD International, Ltd. Used by permission.

P. 10 — © Carnase, Inc. Used by permission.

P. 11 — © DBD International, Ltd. Used by permission.

Pp. 12 -13 — © Oswaldo Miranda/Casa de Idéias. Used by permission.

Pp. 14 - 15 — © 1991 Galarneau & Sinn, Ltd. Used by permission.

Pp. 16 - 17 — © *Rolling Stone* Magazine. Used by permission. Photography © Mark Seliger.

P. 18 — © Tim Girvin Design, Inc. Used by permission.

P. 19 — © DBD International, Ltd. Used by permission.

Pp. 20 - 21 — © *Rolling Stone* Magazine. Used by permission. Photography © Mark Seliger.

Pp. 22 - 23 — © DBD International, Ltd. Used by permission.

P. 24 — © 1988 David Vogler. Used by permission.

P. 25 — © CBS Records. Used by permission.

P. 26 — © David Quay. Used by permission.

P. 27 — © Lubalin Peckolick. Used by permission.

P. 28 — © James Hellmuth Design. Used by permission.

P. 29 — © Arrow Typographers, Inc. Used by permission.

P. 30 — © 1986 Simpson Paper Company. Used by permission.

P. 31 - 33 — © Jacobs, Fulton Design Group. Used by permission.

Pp. 34 - 35 — © Eric Baker, Tyler Blik. Used by permission.

P. 36 — © James Hellmuth Design. Used by permission.

P. 37 — © DBD International, Ltd. Used by permission.

P. 38 — © DBD International, Ltd. Used by permission.

P. 39 — © 1991 Galarneau & Sinn, Ltd. Used by permission.

P. 40 — © Primo Angeli Inc. Used by permission.

P. 41 — © *New York* Magazine. Used by permission.

Pp. 42 - 43 — © DBD International, Ltd. Used by permission.

Pp. 44 - 45 — © Accolade, Inc. Used by permission.

P. 46 — © Bass/Yager & Associates. Used by permission.

P. 47 — © Oswaldo Miranda/Casa de Idéias. Used by permission.

P. 48 — © 1991 Panda Group, Inc. Used by permission.

P. 49 — © Hammond Design Associates. Used by permission.

P. 50 — © Cowell Design Group. Used by permission.

P. 51 — © The Reader's Digest Association Ltd., London. Used by permission.

P. 52 — © *Rolling Stone* Magazine. Used by permission.

P. 53 — © *Newsweek* Magazine. Used by permission.

P. 55 — © PM Typography. Used by permission.

P. 56 — © *Rolling Stone* Magazine. Used by permission. Photography © Matt Mahurin.

P. 57 — © NBC. Used by permission.

Pp. 58 - 59 — © Carnase, Inc. Used by permission.

P. 60 — © Morla Design, Inc. Used by permission.

P. 61 — © 1990 John Stevens Design. Used by permission.

Pp. 62 - 63 — © 1979 International Typeface Corporation. Reprinted with permission from *Upper & Lower Case*, the International Journal of Type and Graphic Design.

Pp. 64 - 65 — © Julian Waters. Used by permission.

Pp. 66 - 68 — © *Rolling Stone* Magazine. Used by permission. Photography © Richard Avedon.

P. 69 — © 1991 Craig W. Johnson. Used by permission.

P. 70 - 71 — © Exxon. Used by permission.

P. 72 — © Tony DiSpigna, Inc. Used by permission.

P. 73 — © Tony DiSpigna, Inc. Used by permission.

Pp. 74 - 75 — © 1990 Emery/Poe Design, Inc. Used by permission.

P. 76 — © Tony Forster. Used by permission.

P. 77 — © DBD International, Ltd. Used by permission.

Pp. 78 - 79 — © *LA Style* Magazine. Used by permission. Photography © Stuart Watson.

Pp. 80 - 81 — © Photo-lettering, Inc. Used by permission.

Pp. 82 - 83 — © Mark Steele. Used by permission.

P. 84 — © Primo Angeli Inc. Used by permission.

P. 85 — © Columbia/Odyssey. Used by permission.

P. 86 — © 1989 John Stevens Design. Used by permission.

P. 87 — © 1986 Daniel Pelavin. Used by permission.

P. 88 — © *Rolling Stone* Magazine. Used by permission. Photography © Herb Ritts.

P. 89 — © Skip Johnston. Used by permission.

P. 90 — © Julian Waters. Used by permission.

P. 90 — © Pushpin Lubalin Peckolick. Used by permission.

P. 91 — © Tony DiSpigna, Inc. Used by permission.

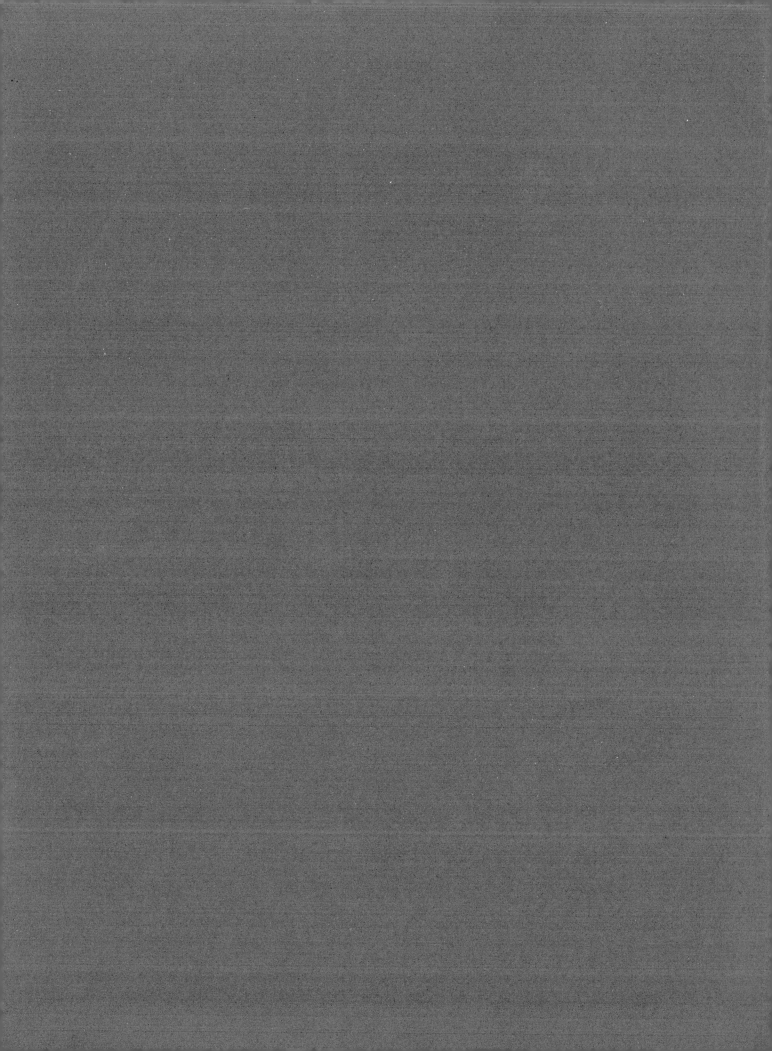